DR

DROITWICH

Drawi
and Pa

Pla

Please return/renew this item by the last date shown

worcestershire
county council
Libraries & Learning

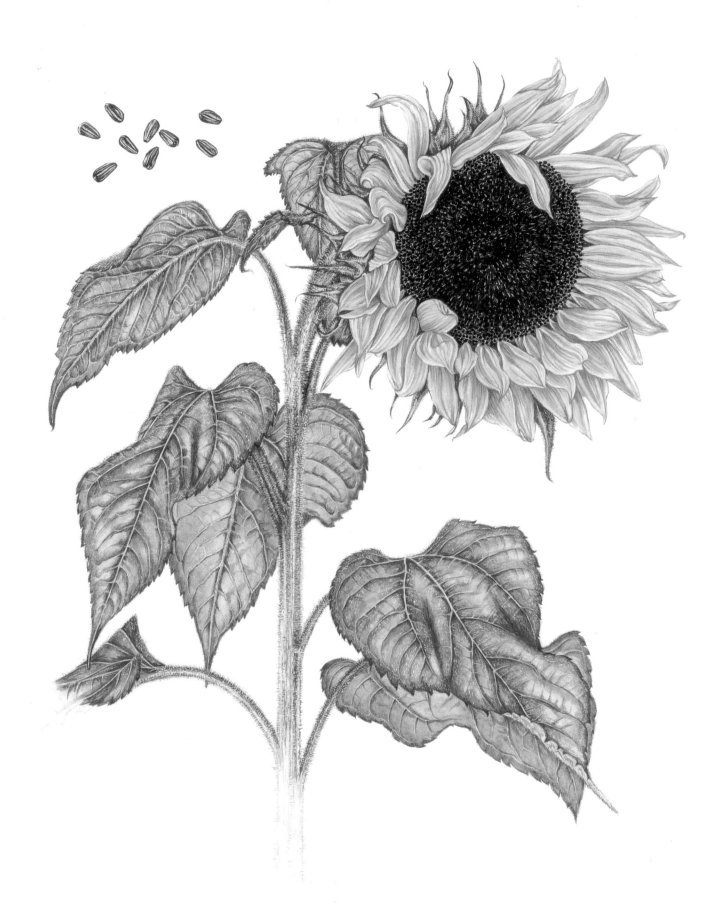

Drawing and Painting
Plants

Christina Brodie

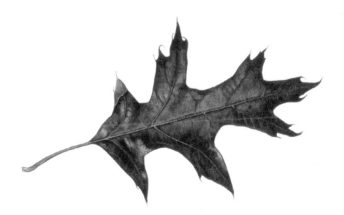

A & C Black
London

FRONTISPIECE Sunflower (*Helianthus annuus*).

First published in Great Britain in 2006
A & C Black Publishers Limited
38 Soho Square
London W1D 3HB
www.acblack.com

Reprinted 2008

ISBN: 978-0-7136-6889-6
Copyright © 2006 Christina Brodie

CIP Catalogue records for this book are available from the British Library and
the U.S. Library of Congress.

Typeset in 11.5 on 15 pt Celeste
Book design: Susan McIntyre
Cover design: Sutchinda Rangsi Thompson

This book is produced using paper that is made from wood grown in managed,
sustainable forests. It is natural, renewable and recyclable. The logging and
manufacturing processes conform to the environmental regulations of the country
of origin.

Printed in China

CONTENTS

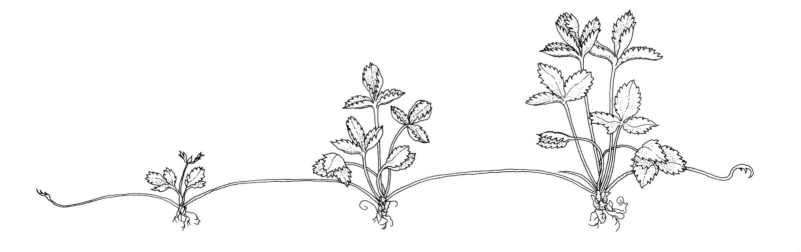

INTRODUCTION

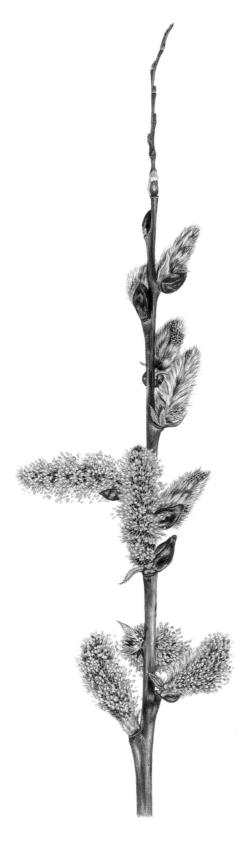

The idea for this book came about through the botanical painting courses I ran for several years at adult education centres in my local area and at RHS Rosemoor; my approach aimed to be a holistic and thoroughly comprehensive one. As they are in this book, drawing and painting techniques were blended with botanical terminology, presentation skills and information regarding the collection of plant material. This provides a highly practical, challenging, but not insurmountable course of study, which I hope will appeal to beginners and more advanced students alike.

I would like to thank the following people: Linda Lambert of A&C Black, for recognising the project's potential; Alan Hepworth, of the Quekett Microscopical Club, for providing the digital photographs from which the paintings of fungi on page 112 were made; Maurice Smith, for loan of the stereomicroscope illustrated on page 84; Simon Leach, Liz MacDonnell, Ron Porley and Jill Sutcliffe of English Nature, for identifying the mosses and halophytic flora on page 136; Margaret Long, of the Société Jersiaise, for identifying the Jersey flora on page 137; and the administration at Dunster Castle, Somerset, England, for allowing me to take photographs of their heritage gardens.

Thanks are also due to John Addison, Head of Horticulture at Cannington College, Somerset, for his memorable teaching; and to all others who have supported my artistic endeavours over the years.

This book is for all who love botanical painting, and would like to deepen their understanding of it at whatever level they choose. I hope that it will bring the reader many hours of pleasure and involvement in the world of plants.

Christina Brodie
October 2005

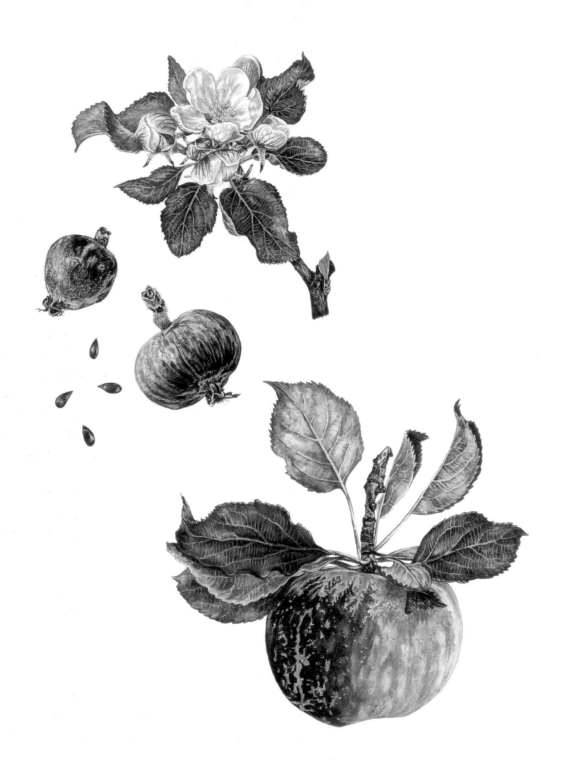

1 THE PLANT KINGDOM

Classification of plants

A background knowledge of plant classification is invaluable for botanical drawing and painting, since the plant morphology, or structure, that you will draw and investigate is directly related to the conditions in which a plant grows and also its mode of reproduction, which leads to the grouping of plants into different categories.

All plants, and related organisms such as fungi and algae, are grouped into categories called **taxons**. The largest taxons represent a grouping of plants that share broadly similar characteristics. These are subdivided into progressively smaller categories until a single species, bearing a specific name, is reached. Classification chiefly takes into account certain physiological features, particularly the presence of a vascular (water-carrying) system within the plant. Vascular plants have an internal system of tubes that transport water throughout the plant; in non-vascular plants, such as algae, water simply moves in and out of the plant by osmosis. Further classification may be made with reference to a plant's mode of reproduction (by spore or seed); its size, shape and colour; the types of reproductive structures that are present; and the presence or absence of certain plant parts.

Classification of plants and related organisms begins with their separation into large groups called **kingdoms**. Thus, plants, fungi and algae are separated into three kingdoms respectively: plants (Plantae), fungi (Mycota) and algae (Protoctista). Traditionally, fungi were classified together with plants, but, since having been recognised as distinct in their own right, they are now placed into a separate category.

Kingdoms are subdivided into **phyla** (singular: phylum). In this book we shall be examining plants from the phyla that are most commonly encountered.

From the Plantae:
- **Anthophyta** (flowering plants) – reproduce by means of flowers. These are further divided into:
 Monocotyledons – one seed leaf, flower parts in groups of three or six, leaves linear.
 Dicotyledons – two seed leaves, flower parts in groups of four or five, leaves complex shape.
- **Coniferophyta** (cone-bearing plants) – reproduce by means of cones.
- **Filicinophyta** (ferns) – reproduce through spores borne in sori on the leaf.
- **Sphenophyta** (horsetails) – reproduce through spores borne on strobili.
- **Bryophyta** (mosses) – reproduce through spores borne in urn-shaped capsules.
- **Hepatophyta** (liverworts) – reproduce through spores borne in round capsules.

The above are all vascular plants.

From the Fungi:
- **Basidiomycota** (basidiomycetes) – reproduce through spores which are shed from the fungal body.
- **Ascomycota** (ascomycetes) – reproduce through spores which are projected from the fungal body.

Fungi are non-vascular organisms made of a proteinaceous material called chitin.

From the Protoctista:
- **Chlorophyta** (green algae)
- **Phaeophyta** (brown algae)
- **Rhodophyta** (red algae)

Algae are non-vascular plants; the larger algae, such as seaweeds, are actually a colony of single-celled organisms. These have many different methods of reproduction and are generally classified according to colour.

The full range of taxons is given below:
Kingdom → Phylum (or Division) → Subdivision → Class → Subclass → Order → Suborder → Family → Subfamily → Tribe → Genus → Section (or Series) → Species → Subspecies → Variety or Form → Cultivar

Botanists around the world have different methods of classifying plants according to the system shown above; the method of classification

Plant groups.

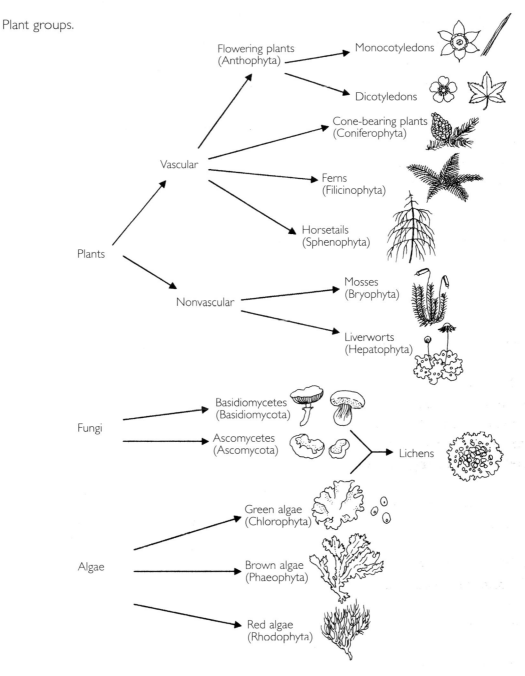

usually varies from country to country, and often from one botanist to another. Both higher and lower taxa have recently been subject to frequent and extensive renaming; significant has been the recent renaming of some of the larger plant families. Taxonomic classification often changes so quickly that it is almost impossible for non-specialists to keep pace with every development. However, learning the names of every division to which each plant belongs is not strictly necessary; generally, the highest and lowest taxa are the most important, and the easiest to remember. The three types of taxa that botanical artists most commonly use are the **family**, **genus** and **species**.

Family, genus and species

A **family** is a group of one or more genera that shares a number of underlying features. In flowering plants, similarity of floral shape and structure is the main reason for inclusion in a family. Recent subdivision of some of the larger plant families has led to extensive renaming; for example, the Compositae (Daisy family) is now known as the Asteraceae, and the Graminae (Grass family) as the Poaceae. The Leguminosae (Pea family) has been divided into Fabaceae and Papilionaceae. Older botanical names are likely to be present in literature published over ten years ago. You are unlikely to be censured for using an older name, since most of the names are still common knowledge. However, it is good practice to update your knowledge of this area on a regular basis.

A **genus** is a group of one or more species that share a wider range of characteristics than plants within a family, and is therefore usually, but not always, a smaller group. This group often has a generic name: for example, *Fagus* denotes beech, or *Salix* denotes willow. The name given to a genus forms the first half of a plant's botanical name, and is printed in italic type with an initial capital letter (e.g. *Fraxinus, Quercus*). A multiplication sign before the generic name denotes a hybrid; thus the Leyland cypress, which is a hybrid between the *Cupressus* and *Chamaecyparis* genera, is written as 'x *Cupressocyparis*'. Where single botanical names are mentioned throughout this book, an unidentified member of a particular genus is denoted.

A **species** is a group of plants that it is possible to breed together in order to produce offspring that will be similar to themselves. The species name forms the second half of a plant's name, and is printed in italic type, entirely in lower case. For example, the *robur* in *Quercus robur* is the species name, and denotes the type of oak, since there are many different types.

The following three taxa may also be useful. They fall below the family, genus and species in the taxonomic hierarchy.

The **subspecies** is a naturally occurring and distinct variant of a species. It is described by adding 'subsp.' to the botanical name in Roman type, with the subspecies name following in italic type. An example would be *Prunus lusitanica subsp. azorica*.

The term **variety**, or **form**, is given to minor subdivisions of a species where the plants differ only slightly in their structure. These are indicated by 'var.' or 'f.' in Roman type, followed by the name of the variety or form in italic type, as in *Rosa gallica* var. *officinalis*.

Cultivars are cultivated plants that have been specially selected for a distinguishing characteristic. They are distinct variants of species, sub-

species, varieties, forms or hybrids. They are indicated by a vernacular name in Roman type, contained within inverted commas, following the species, subspecies or variety name. In the event of the plant's parentage being extremely complex, the cultivar will be referred to by the genus name followed by the cultivar name, as with *Rosa* 'Cordon Bleu'.

Botanical terminology in this book

Throughout this book I have attempted to refer to each illustrated plant using their genus name wherever possible, even if the species, variety or cultivar is not known. The genus name is the one, usually given in brackets, beginning with an initial capital letter and printed in italic type, following the vernacular plant name: for example, oak (*Quercus*).

2 DRAWING AND WATERCOLOUR TECHNIQUE

Drawing and painting materials

Botanical painting need not be an expensive pursuit; what is most important is the ability of the materials to perform their task well, and the skill of the painter. Good results can be achieved with a minimum of investment and refined technique. Even if used on a constant basis, many of the materials, such as watercolour paints or pens, should last for years.

The illustration below suggests some of the media with which you may want to experiment. Beginners may prefer to start with watercolour or dip pen, whereas painters with a moderate to advanced level of skill may wish to progress to using opaque media such as gouache or acrylic, a command of which is necessary to portray some of the more challenging subjects shown in later chapters.

Your first investment should be in an A3 or A4 pad of smooth-surfaced heavyweight cartridge paper (220 g/m²), such as that available in the UK from Daler-Rowney. Botanical painting requires an artist to

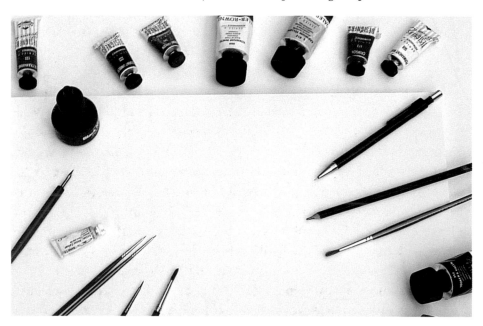

Some of the materials used in botanical painting; heavyweight cartridge paper; dip pen and ink; watercolour, gouache and acrylic paints; variously sized round synthetic watercolour and acrylic brushes.

render the subject in a fine degree of detail; the rough or textured surfaces of many watercolour papers will scatter light and obscure fineness of detail. The surface of watercolour paper also absorbs paint like a sponge, so does not make it easy to work quickly. It also does not easily support media such as ink or pencil. Therefore, it is best to use smooth-surfaced general-purpose papers and boards, such as the cartridge paper mentioned above, or hot-pressed illustration board that is suitable for line and wash work. These surfaces are designed to support a wide range of media, such as pencil, ink, watercolour, gouache and acrylic, and do not need to be pre-stretched.

The heavyweight cartridge paper used for the illustrations throughout this book is inexpensive to purchase and has an attractive, smooth, cream-coloured surface. It is not suitable for wet-in-wet technique; those who are accustomed to working in this manner may find that some adjustment to their painting technique is necessary, as cartridge paper does not have the absorbency of watercolour paper, and the smooth surface will be spoiled and disintegrate if over-wetted. Some control will therefore be needed over paint consistency and the application of paint layers.

Conventional standard copier paper (not coated or specialist) may be used for ink drawings that are intended for reproduction only and not display. If intended for display, an investment should be made in the luxury of hot-pressed illustration board. Illustration board is pure white, has a beautiful smooth-textured surface giving a 'professional' finish, and allows for an even laying down of washes. Also, paint on this surface will stay wet for slightly longer than on cartridge paper, so that colours diffuse into each other. (A description of board types and suppliers can be found in the Appendix.)

Drawing and watercolour technique

For drawing, a propelling pencil with a 0.5 mm HB lead is preferable to a traditional wooden pencil, since it does not need sharpening and will not smudge as easily. A plastic eraser is also preferable to a kneadable eraser since the latter becomes oily and will leave a residue on the paper. The best palette to use is a glazed white china plate, since it is easier to clean than a plastic palette, particularly if using acrylic paints, which are themselves a form of plastic and will set hard when dry.

Brushes should be wholly synthetic, as sables and sable/synthetic blends are not robust and are liable to be ruined within a very short time. The brushes I use are of a 'round' type (Daler-Rowney Series 111); I would recommend sizes 4 and 7 for laying down large areas of colour, and size 0000 for detailed work. Watercolour brushes should be used for

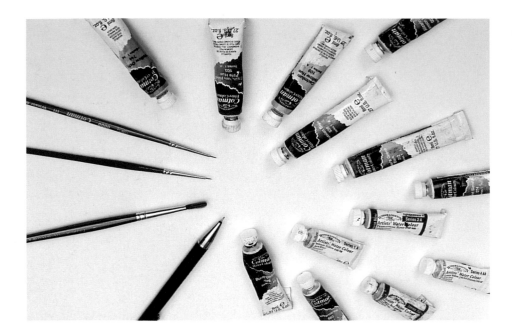

Watercolours with watercolour brushes and propelling pencil.

watercolour painting; acrylic brushes for gouache and acrylic painting. The finest size of watercolour brush can, however, be used to paint fine detail in gouache and acrylic paintings. If painting is your full-time occupation, you can buy fine brushes in bulk; each one will have a life expectancy of two or three weeks.

Watercolours are supplied in tubes or pans; both are equally suitable for beginners, although tubes allow fresh paint to be used each time and do not soil quickly, as pans do. It is advisable to purchase 'artists' quality' watercolours, since these are usually provided with a longer guarantee against fading.

Prior to commencing work, with a set-square I rule a faint border inside the edges of my sheet of paper, between 1 and 2½ inches wide

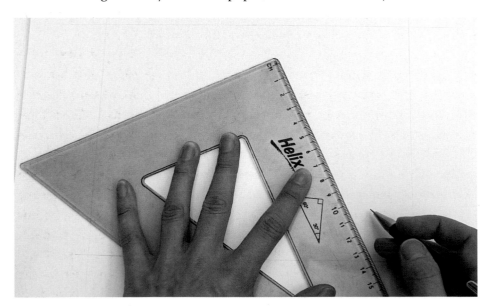

Ruling a border.

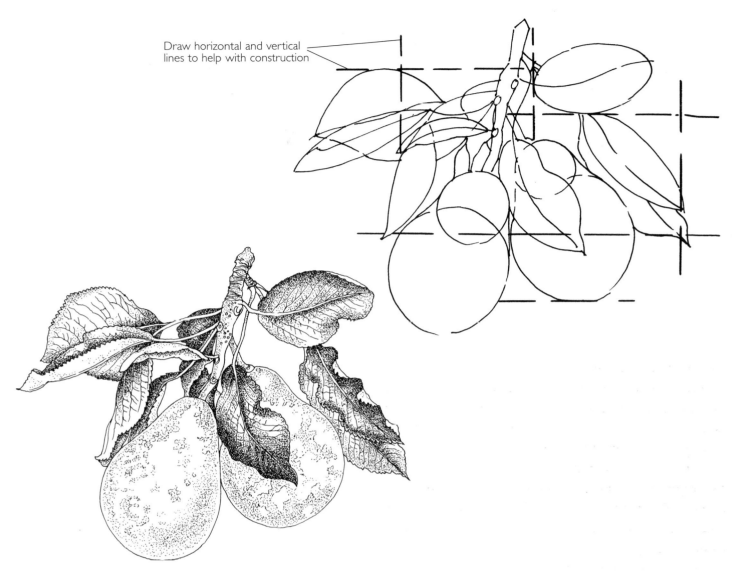

Draw horizontal and vertical lines to help with construction

How a drawing can be constructed from basic shapes.

depending on the paper size. This provides a 'frame' within which to work on the painting, gives a guideline for mounting or framing, and prevents soiling of the painting through handling.

It is essential to draw your subject in full detail before painting it, for the reason that subsequent painting is likely to be easier, quicker and more accurate. Provided pencil marks remain sufficiently light, they can be gently erased or covered with paint or another medium at a later stage. Drawing the subject accurately is fundamental to your painting; the accuracy of a foundation drawing will invariably affect the finished work.

Plan your drawing on the sheet of paper, using a light pressure so that your pencil marks can be easily erased later and will not blemish or groove the surface of the paper. Use straight or curved lines to plot stems and leaves, and basic shapes – circles, ovals, ellipses, diamonds, trapezia or kidney-bean shapes – to plot subjects such as flowers. Horizontal and vertical construction lines will also assist in the alignment of parts of the plant, so that the final drawing is in proportion and appears visually

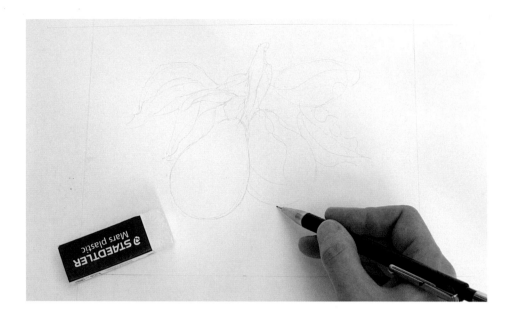

Plotting the drawing.

correct when paint is applied. Awkward shapes can be obtained from the amalgamation of several basic shapes, and drawings of subjects that change shape according to viewpoint can be constructed from different basic shapes.

Using the construction lines and basic shapes of your sketch as a guide, begin to refine your drawing. Each individual part of a plant has a shape or form of its own, which must be accurately defined. At the very least, the aim should be to define all forms comfortably visible to you with the naked eye. For example, all petals, or all leaves, should be distinct from each other and clearly defined, but certain floral parts may sometimes be insufficiently large to be shown in this manner. Your drawing should be as crisp and as clear as possible, so that the plant species it represents can be clearly identified from it.

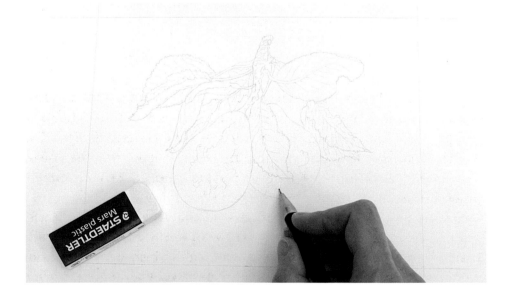

Refining the drawing.

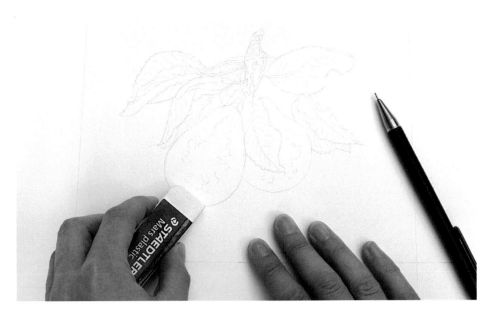

Erasing construction lines.

The finished drawing.

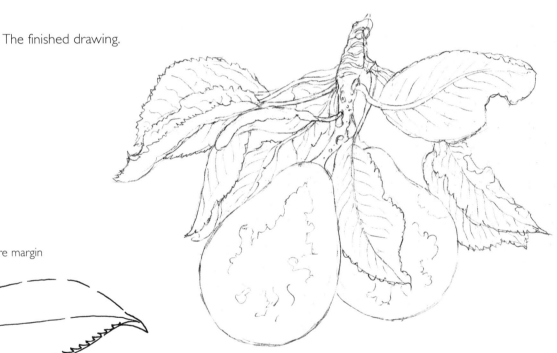

Block in an entire margin

Use the construction line to
help draw a serrated margin

Drawing complicated margins.

Continuity should be present in complicated margins such as those found along a carnation petal or serrated leaf. Sketch in the outline of a margin, then work over it, drawing in any serration or crenellation. This will create a smooth, definite flow of movement, preventing the line of the margin from meandering or being drawn off scale, which is often a problem if guidelines are not used.

Only draw outlines; do not draw in shadows of any type at this stage, since pencil marks may show through light washes when paint is applied later. If patterns or markings are present, lightly indicate the edges of these. Erase your construction lines on completion of the detailed drawing.

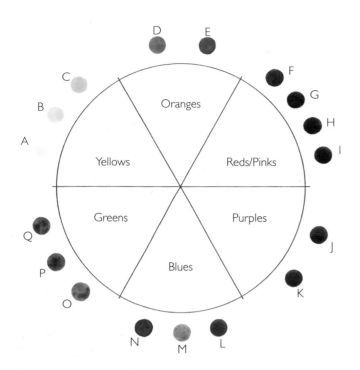

Colour wheel.

KEY
A – Lemon Yellow
B – Winsor Yellow
C – Cadmium Yellow Hue
D – Cadmium Orange Hue
E – Cadmium Red Pale Hue
F – Winsor Red
G – Alizarin Crimson
H – Permanent Rose
I – Quinacridone Magenta

J – Mauve
K – Dioxazine Violet
L – Ultramarine
M – Cerulean
N – Prussian Blue
O – Viridian
P – Hooker's Green Dark
Q – Hooker's Green Light

KEY COLOURS				
Yellows	A	B	C	
Oranges	D	E		
Reds/Pinks	F	G	H	I
Purples	J	K		
Blues	L	M	N	
Greens	O	P	Q	
Earth Colours/Neutrals	R	S	T	U

Suggested paint colours, from the Winsor and Newton 'Artists' and 'Cotman' ranges.

KEY
A – Lemon Yellow
B – Winsor Yellow
C – Cadmium Yellow Hue
D – Cadmium Orange Hue
E – Cadmium Red Pale Hue
F – Winsor Red
G – Alizarin Crimson
H – Permanent Rose
I – Quinacridone Magenta
J – Mauve
K – Dioxazine Violet
L – Cerulean Blue Hue
M – Prussian Blue
N – Ultramarine
O – Hooker's Green Light
P – Hooker's Green Dark
Q – Viridian Hue
R – Yellow Ochre
S – Burnt Sienna
T – Burnt Umber
U – Ivory Black

Colours

The colours suggested below are only a guideline, since colour recipes and qualities will vary from range to range. These are the basic colours that I use personally, that I have found to be adequate for my needs and which fall within an affordable budget. However, there should be no restrictions on the colour range you choose to use. It is perhaps best to buy a standard set of tube or pan watercolours and augment your colour range gradually by purchasing individual tubes or pans.

It is important to have good 'cool' and 'warm' versions of your various colours. 'Cool' in this instance denotes a colour with greener or bluer overtones, whereas 'warm' describes a colour with overtones of yellow or red. It is a good idea to spot your colours on a colour wheel to assess their relative warmth or coolness to one another.

To appreciate the qualities of your individual colours and familiarise yourself with your palette, it will be necessary to make colour charts using groups of colours within a certain range. For example, colours with yellow overtones are mixed with colours with blue or green overtones in the chart below, to create a variety of greens. It can be seen that the clearer and more vibrant colours produce the brightest greens, and that cooler colours produce cooler greens. Warmer colours such as ultramarine (a warm blue) or light orange, or earth colours such as yellow ochre, will produce more muddied greens.

These colour charts can subsequently be matched to any subject that you are painting and an accurate colour blend picked out; for this purpose they prove an invaluable time-saver.

Colour matching and shading in colour

Some artists advocate the use of a complementary colour, or grey, to shade; whilst this technique can be used to some effect, I find the brightness and purity of flower colour is best preserved in watercolour paintings by using a darker, or less dilute, version of the same, or a similar, colour. A little grey may be used in shading pale-coloured flowers, however, though some caution should be exercised when doing so, as shading may be very easily overdone.

White flowers can be shaded and outlined using a very pale grey mixed from Permanent Rose and Viridian. Alternatively, a similar red-pink and blue-green, which are opposite each other on the colour wheel and will therefore produce a grey, may be used. White flowers are rarely completely white; many have a hint of some colour present (see also Chapter 9). In white flowers, and in some paler-coloured ones, coloured reflections are likely to occur. The sources of these may be either internal to a flower (patterning or colour on the inner petals), or external (the coloured petals of another flower). The reflections may range in colour from yellow through to pink, blue and pale green. Look for these reflections in white or paler-coloured flowers and endeavour to include them in your painting. An example is present in the painting of the rose shown on page 25. Representation of these reflections breathes life and warmth into the painting, imbuing it with a three-dimensional quality.

Yellow flowers should be shaded with the grey mix used for shading white flowers, adding a touch of yellow ochre. Special care must be taken not to 'over-grey' yellow flowers. Red flowers may be shaded with alizarin crimson, or a mixture of cadmium red and permanent rose. Mauve may be very occasionally used in the darkest areas. This same method of shading with a darker colour may be applied to blues, greens and earth colours in turn.

Certain colours can be matched to the base colours of certain flowers. For example:

Lemon Yellow – Primrose	Ultramarine – Grape hyacinth
Winsor Yellow – Celandine	Dioxazine Violet – Violet
Cadmium Orange – Wallflower	Permanent Rose – Rose
Winsor Red – Quince	Quinacridone Magenta – Cyclamen
Cerulean – Gentian	

Colour chart: mixing yellows and blues to create greens.

KEY
A – Lemon Yellow
B – Winsor Yellow
C – Cadmium Yellow
D – Yellow Ochre
E – Cadmium Orange
F – Hooker's Green Light
G – Hooker's Green Dark
H – Viridian Hue
I – Cerulean Blue Hue
J – Prussian Blue
K – Ultramarine

Watercolour painting – technique

The following technique is the basic painting technique that I use when working in watercolour. However, its underlying principles can be just as easily applied to other painting and drawing media (see Chapters 5 and 6).

The basic technique consists of laying progressively darker washes down using the largest brush that is appropriate for the task: for example, a size 4 for general work, or size 2 for smaller flowers. Paint consistency is very important; neither a wet- nor dry-brush technique is used. Instead, the paint consistency should fall somewhere in between the two, so that it covers the paper easily without over-wetting. With practice you will find the consistency becomes easier to assess; it is recommended that you test it first on a swatch of spare paper.

The painting is then shaded using the fine oooo brush and small, hairlike strokes that blend into one another; the short bristles of the brush make it easier to control than liner or rigger brushes. Using progressively darker shades of paint will result in an area of graduated tone.

With an appropriate brush size and colours, the painting should then be further enhanced to achieve a simultaneous naturalism and a crisp clarity. Outlines should not be uniform; instead, the outline thickness should vary. In darker areas, shading should be blended from the outline to achieve continuity of the surface's form.

I sometimes work over parts of the painting with permanent white gouache, which in a dilute form can emulate a whitish 'bloom', as well as highlighting specific areas, and emphasising solidity and reflectivity. These areas are then reworked in colour to give a clear final result.

The qualities of watercolour

Watercolour, unlike some other paint media, has a translucency that lends itself especially well to the depiction of flowers. Flowers have an ethereal quality, and simultaneously a vibrancy and a softness that watercolour appears to be the best medium for expressing. Watercolour is the most popular and widely used medium in botanical art, and most botanical artists use it exclusively. Also, it does not dry as quickly as gouache or acrylic and thus is easier to use, particularly when applying washes.

Single washes of watercolour will tend to be less intense than single washes of gouache or acrylic, since the pigment is less concentrated. This quality can be exploited through the very sensitive use of shading.

OPPOSITE This painting shows how certain colours can be matched to particular flowers.

CLOCKWISE FROM LEFT Lemon Yellow – primrose; Cerulean – gentian; Winsor Yellow – celandine; Ultramarine – grape hyacinth; Cadmium Orange – wallflower; Winsor Red – quince, Dioxazine Violet – violet.

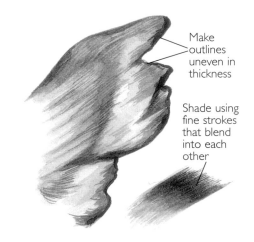

Make outlines uneven in thickness

Shade using fine strokes that blend into each other

Shading using fine hairlike brushstrokes.

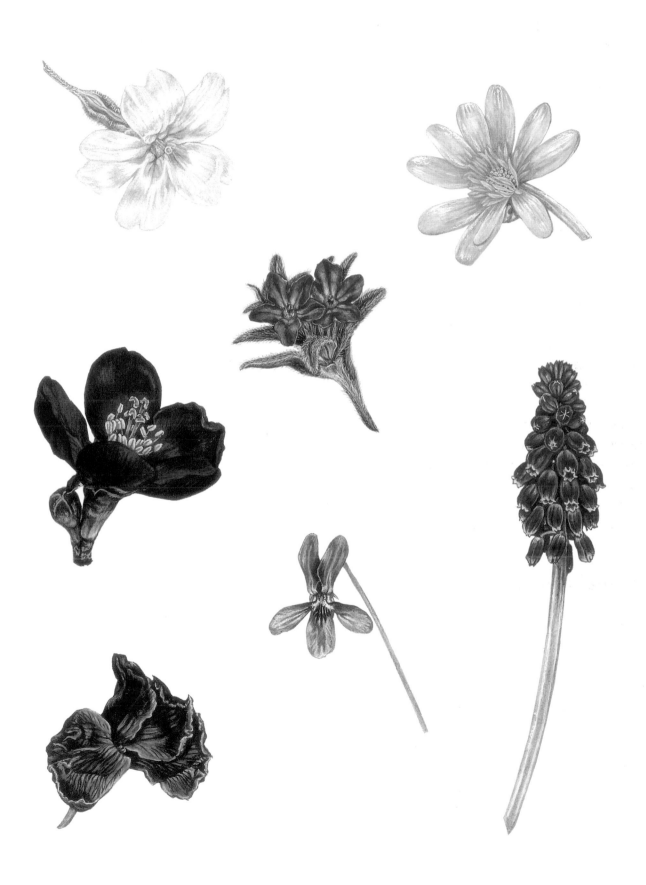

Painting a rose

1 Draw the rose in detail, in pencil.

2 Mix up a wash of the lightest colour present, using a swatch of paper to test the colour and paint consistency, and paint the relevant areas using a size 4 brush.

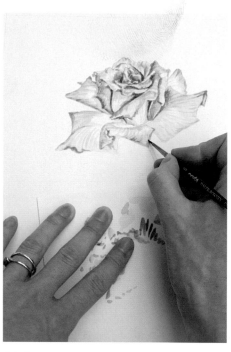

3 Mix up progressively darker versions of the same colour, and shade darker areas using the shading technique and your fine 0000 brush.

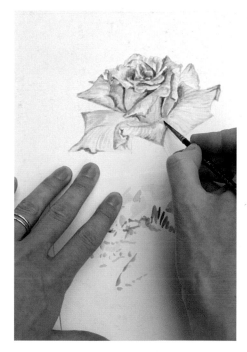

4 Paint in any other colours or reflections visible, such as the intense yellow glow towards the centre of the rose.

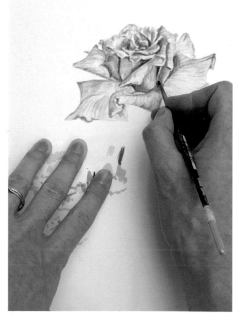

5 Use a pale grey (a mixture of Permanent Rose and Viridian) to apply shading to almost-white areas and give the rose form.

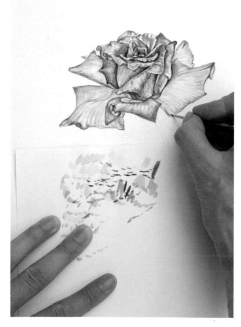

6 Intensify and deepen the shading over all areas of the rose.

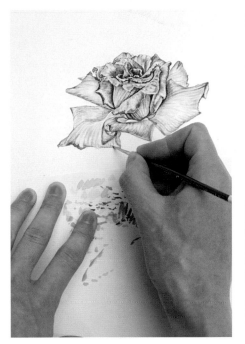

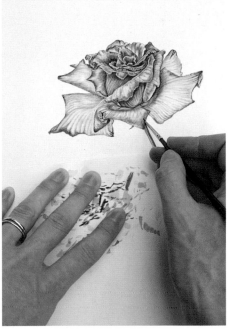

7 Use Permanent White gouache in highlighted areas to give the petals solidity and form, working over the whole flower.

8 Further intensify the colour over the whole flower.

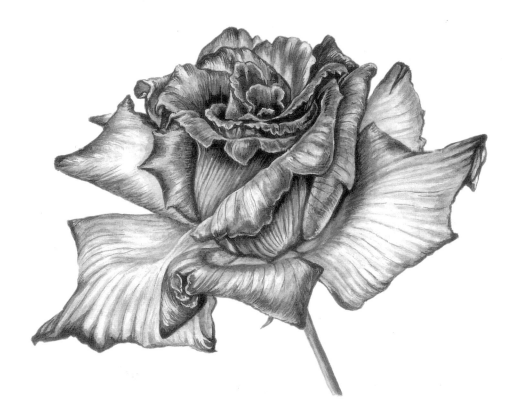

The finished painting.

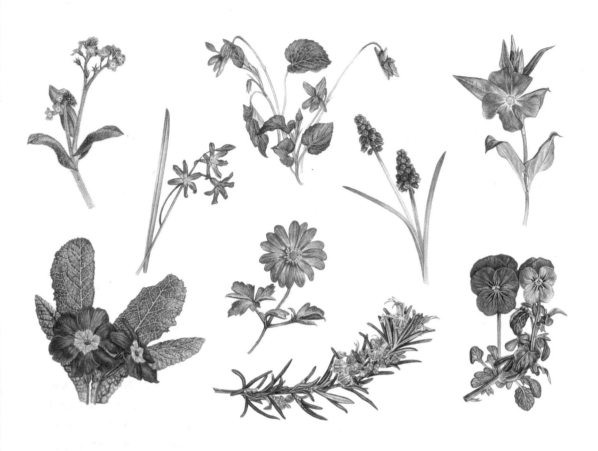

Blue spring flowers.
CLOCKWISE FROM TOP
Forget-me-not (*Myosotis*
sp.); *Chionodoxa*; sweet
violet (*Viola odorata*);
grape hyacinth (*Muscari*);
periwinkle (*Vinca major*);
Viola cv.; rosemary
(*Rosmarinus officinalis*);
Anemone blanda; *Primula* cv.

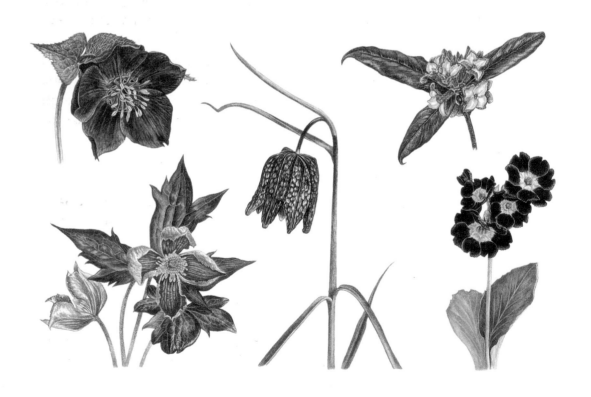

Red-purple spring flowers.
CLOCKWISE FROM LOWER
LEFT *Clematis* cv.;
Helleborus cv.; snakeshead
fritillary (*Fritillaria meleagris*);
Daphne odora; auricula
(*Primula* sp.).

3 FLOWERING PLANTS:
Flowers, Fruits & Seeds

Parts of a flower

Before commencing the exercises in this chapter, I recommend obtaining a suitably large flower, in order to familiarise yourself easily with its different parts; a large lily flower is ideal. In order to fully appreciate the floral structure, it may be necessary to dissect the flower; instructions for dissection of various types of flower are given later in this chapter.

The flower is the part of the plant that produces seed. Reproduction by seed is different from vegetative propagation through root or stem cuttings, where new shoots may arise from a section of stem or leaf and produce a new individual genetically identical to the parent plant. Reproduction by seed allows for genetic variation between parent plants and offspring, since the pollen that fertilises a flower often comes from a different flower or plant.

Fertilisation of a flower arises when pollen is transferred from the male parts of a flower to the female parts, a process called **pollination**. This may be carried out through the motion of wind or water, or through insect activity. The male parts of a flower are called the **stamens**; the female parts, the **carpels** or **pistils**.

Male part (stamen)
This is comprised of the **anther** and **filament**. The anther is the part of the flower that produces pollen and is carried at the top of a stalk (the filament).

Female part (carpel or pistil)
This comprises the **stigma**, **style** and **ovary**.

The stigma is located at the top of a stalk (the style), and receives pollen from the anthers of the same, or another, flower. At the base of the style is the ovary, which may have one or more chambers, and contains **ovules**, or immature seeds.

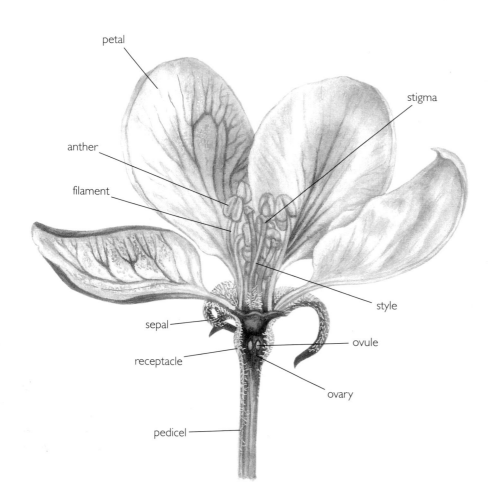

petal

anther

filament

stigma

style

sepal

receptacle

ovule

ovary

pedicel

Other parts of the flower play a protective or supportive role, such as the **corolla**, **calyx**, **receptacle** and **pedicel**.

Corolla

This is the part of the flower directly surrounding the reproductive parts, and is made up of **petals**. As well as serving the purpose of protecting the reproductive parts, the petals may be adapted to attract insect pollinators, being brightly coloured, patterned or curiously shaped.

Calyx

This is the outer part of the flower, made up of **sepals**, which are located outside the petals. These may have a greenish tinge, or they may be completely indistinguishable from the petals. They protect the petals and inner floral parts at night, and when the flower is in bud.

The calyx and corolla taken together are called the **perianth**. In monocotyledons such as lilies, sepals are generally indistinguishable from petals. The sepals and petals may then be referred to as **tepals** or **perianth segments**.

Receptacle

The receptacle is the swollen end of the flower stalk that supports all floral parts.

Pedicel

The flower stalk is termed the pedicel.

The diagram on page 28 represents an idealised flower. However, as we shall see, there are many variations on this theme. Flowers may have both male and female parts (hermaphrodite or bisexual), as described above, or they may have only male or only female parts (unisexual). They also present a limitless variety of shapes and forms, as a study of different families and genera will reveal.

Symmetry in flowers: actinomorphic and zygomorphic flowers

An **actinomorphic** flower is one which is radially symmetrical: it can be divided into equal segments which meet at the centre.

A **zygomorphic** flower is one which is bilaterally symmetrical: it can be divided down its centre to produce two halves which are mirror images of each other.

Actinomorphic and zygomorphic flowers.

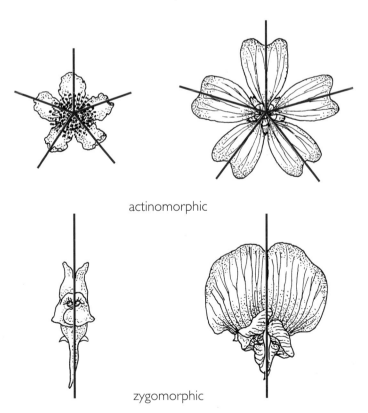

actinomorphic

zygomorphic

More complex flowers

Grass family (Poaceae or Graminae) flowers have no petals, and adjacent **florets** (literally, 'small flowers') are instead enclosed in a group called a **spikelet** by tough **bracts** (leaflike structures) called **glumes**. Individual florets are further enclosed by bracts termed according to their respective positions: the **lemma** (inner bract) and **palea** (outer bract). Grass florets generally have one carpel with a feathery stigma to catch wind-borne pollen, and three stamens.

Aroid (Araceae) family flowers consist of a large bract, called a **spathe**, surrounding a foul-smelling spike, or **spadix**. This has a hair trap, to trap insects, situated about halfway down. The insects that are trapped fall to the bottom of the spathe. On their way down they brush past the male flowers. Their only means of escape will be to crawl up the spadix, brushing past, and thus pollinating, the female flowers on their way.

Irises (family Iridaceae) are actinomorphic, and are made up of a group of three upright petals, called **standards**, a group of three **petaloid** (petal-like) stigmas, and a group of three drooping petals called **falls**. The stigma is situated along the upper edge of the petaloid structure. When an insect lands on the fall in search of pollen or nectar, its body contacts the anther as it enters the flower, then brushes against the stigma as it exits. Bearded irises also have a patch of fine hairs on their falls, called **beards**, that catch any stray pollen in order to conserve it.

Grass flower.

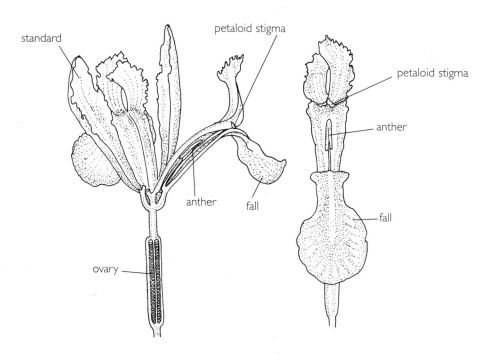

Iris flower, in longitudinal section; one petaloid stigma, anther, and fall.

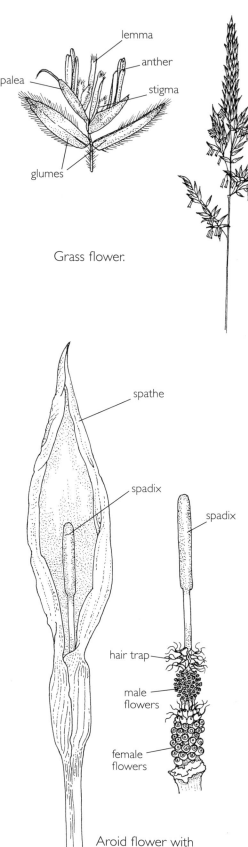

Aroid flower with spadix and spathe.

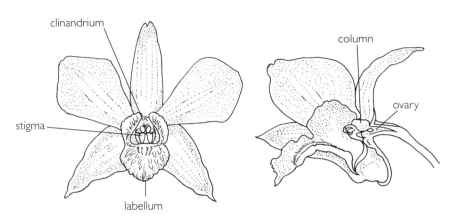

Orchid flower, in front view and longitudinal section.

Orchid (Orchidaceae) flowers are zygomorphically have a highly evolved anther (**clinandrium**) and stigma, which are fused to form a structure called a **column**. The lower of the three petals is usually enlarged and may form a landing platform for pollinators; in this instance it is referred to as a **labellum**. The three sepals are, as in many monocotyledons, indistinguishable from the petals.

Passion flowers (Passifloraceae) have a reproductive structure called an **androgynophore**, which carries both male and female parts. The area between the outer and inner rings of **corona filaments** acts as a landing platform for pollinators; movement of the pollinator around the platform ensures contact with any of the five anthers and terminations of the three-pronged stigma in turn. Conventionally, there are ten perianth segments. An analogy was traditionally made between the distinctive set of numbers of floral parts present in this family, and the elements of Christ's Passion; hence the name.

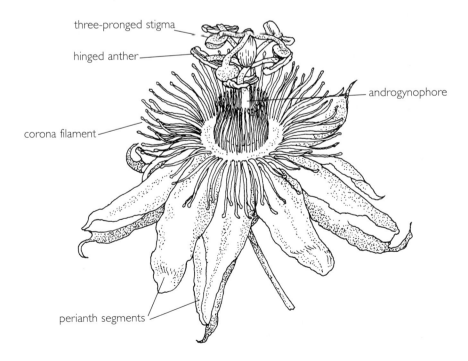

Passion flower.

In the spurge, or euphorbia, family (Euphorbiaceae), separate flowers are carried within a cuplike flowering head, or **inflorescence**. The flowers have no petals, and are instead surrounded by two large bracts. Nectar-secreting glands are found around the edge of the cup; the shape of these will vary according to the species. The male flowers, with one stamen, are carried inside the cup; the female flower, with three stigmas, hangs outside the cup on its style.

Catkins are found across a number of tree families, such as beech (Fagaceae), hazel (Corylaceae) and birch (Betulaceae). They are clusters of either solely male or solely female flowers; the sexes are not mixed within one flower, although different sexes of flowers may be present on the same tree.

Amaryllids (Amaryllidaceae), such as daffodils, have a trumpet-shaped structure, the **corona**, situated at the centre of the flower and surrounded by a multiple of six perianth segments. The corona and perianth segments fuse halfway down the floral structure to form a **perianth tube**.

A flower typical of the pea family (Papilionaceae/Fabaceae or Leguminosae) is zygomorphic, and is composed of a lower petal, the **keel**, enclosed by two side petals, the **wings**; the wings are in turn enclosed by the top petal, or **standard**.

Daisy family (Asteraceae or Compositae) flowers have **composite** flower heads. The flower head, or **capitulum**, is made up of many tiny flowers of two types: **disc florets** and **ray florets**. Disc florets are found at the centre of the flower, and at low magnification can be seen to be tubular, with five fused petals. Ray florets are found around the outer edges of the flower, are petal-shaped, and serve to attract pollinators. Both types of flower may be wholly male, wholly female or hermaphrodite (with both male and female parts), and some flowers may consist only of disc (thistle) or only of ray (dandelion) florets.

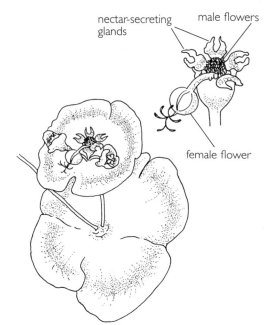

Spurge flower.

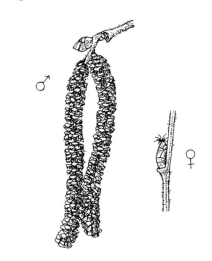

Male and female catkins of hazel.

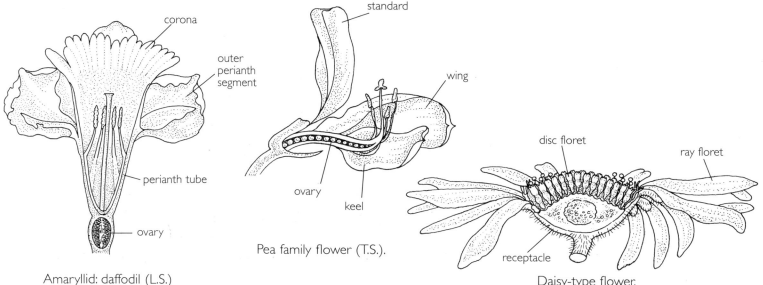

Amaryllid: daffodil (L.S.)

Pea family flower (T.S.).

Daisy-type flower.

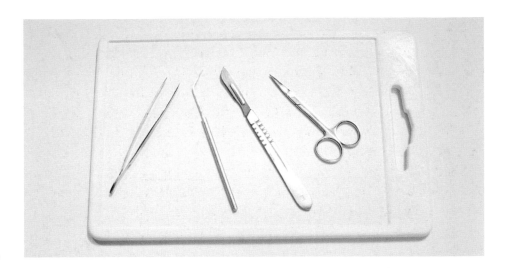

Dissection kit.

Dissections

For all dissections it is necessary to acquire a simple dissection kit. This should include a scalpel and blades, scissors, a dissecting needle, and tweezers; a cutting board will also be needed (for a supplier see Appendix).

It is vital to take the utmost care when handling dissecting scalpels. These are extremely sharp and designed to cut through tough plant material and flesh. For this reason, it is important to work slowly and carefully, giving full concentration to the task. Wrap the instrument in a soft cloth when not in use, and store in a safe place to avoid accidents.

Though the dissection procedure varies slightly for actinomorphic, zygomorphic and composite flowers, and also between individual genera, bear in mind that your aim will be to create a view of a half-flower conveying as much information as possible about the flower interior.

Dissecting actinomorphic flowers

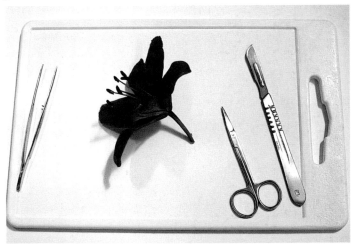

1 Choose a large actinomorphic flower, such as a lily, from which to work.

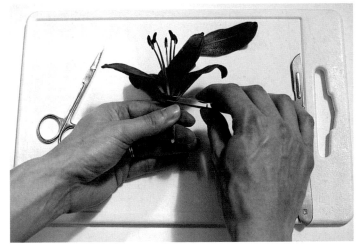

2 Using tweezers, remove one perianth segment from one side.

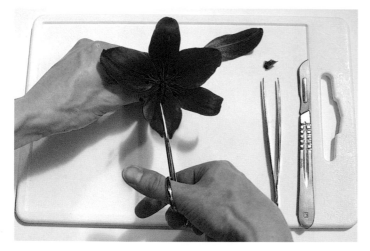

3 Using scissors, start to cut down the length of a perianth segment adjacent to the one that has been removed.

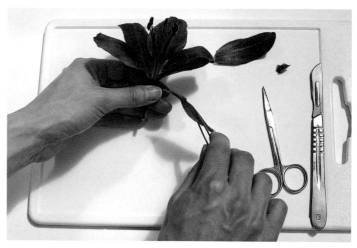

4 Remove the half-perianth segment using tweezers.

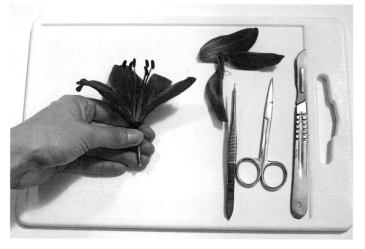

5 Do the same for the perianth segment on the opposite side of the flower.

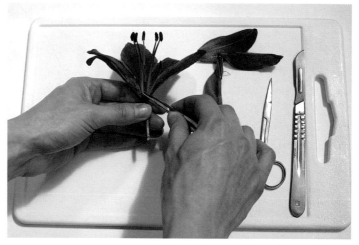

6 Using tweezers, remove the stamens covering the ovary.

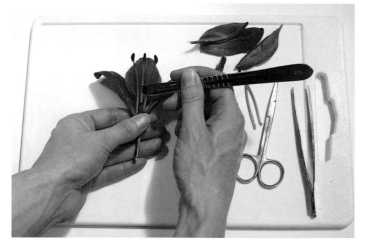

7 If possible, and with care, use the scalpel to bisect the ovary to reveal the ovules.

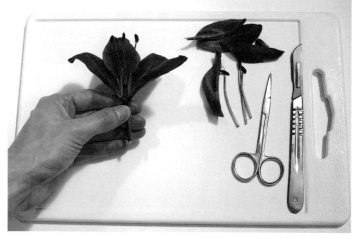

8 The completed half-flower.

Dissecting zygomorphic flowers

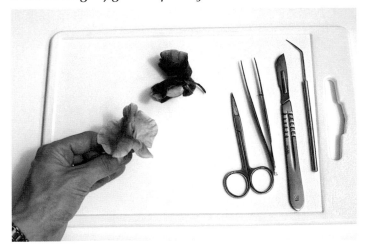

1 Select a zygomorphic flower, such as a sweet pea.

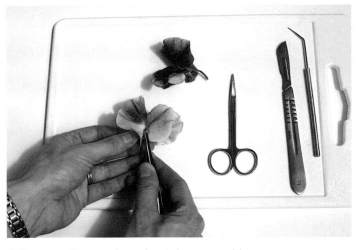

2 Remove the sepals and petal on one side.

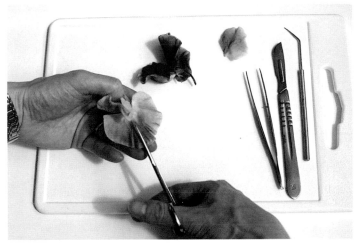

3 Cut along the length of the standard with the scissors, and remove the half adjacent to that which has been removed using tweezers.

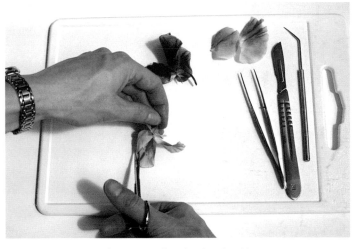

4 Repeat the previous step for the keel, taking care not to damage any inner floral parts.

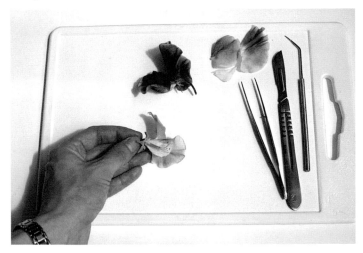

5 The half-flower almost complete.

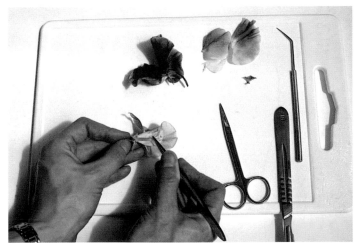

6 Remove the stamens surrounding the ovary using tweezers.

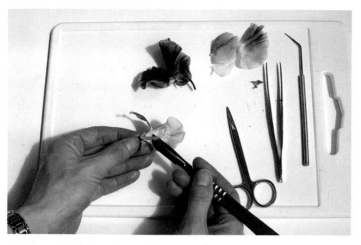

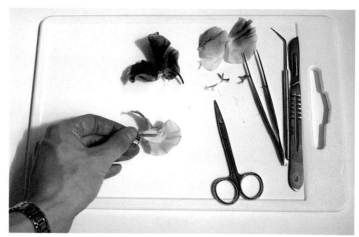

7 If possible, slice through the ovary using the scalpel, to expose the ovules.

8 The completed half-flower.

Dissecting composite flowers

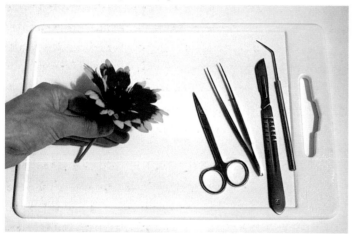

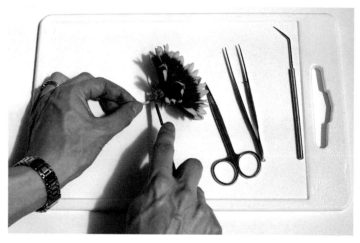

1 Select a large composite flower, such as an ox-eye daisy or gaillardia.

2 Remove the pedicel (stalk) a short distance below the receptacle.

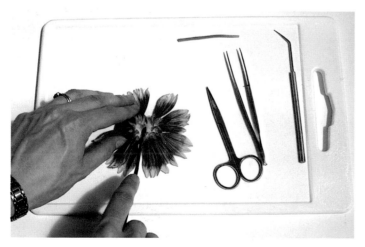

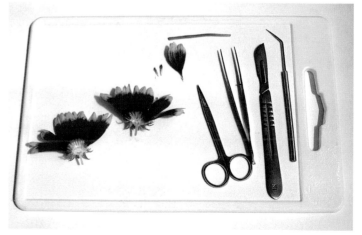

3 Turn the flower upside down on the cutting board and cut in half using the scalpel.

4 Two completed half-flowers.

FLOWERING PLANTS: FLOWERS, FRUITS & SEEDS 37

Inflorescences

An inflorescence is a flower head, and occurs in a number of arrangements, usually relating to the way in which the stem is branched.

Solitary inflorescences consist of just one flower, borne on a stem which does not subdivide as it does in other inflorescences. (Note that the capitulum of composite flowers is taken to be a solitary flower head.)

A **raceme** has flowers positioned on stalks alternately up the stem. The oldest flower is at the base of the stem, the youngest near the top. Strange as it may seem, catkins in fact fall into this category.

Cyme inflorescences typically show younger flowers arising from side branches of a stem that already terminates in a flower. Thus, in **monochasial** or **scorpioid** cymes, single stems branch off the main and each subsequent stem. Dichasial cyme inflorescences are not dissimilar to corymbs (see below); key differences, however, are the repeated division of the stem into two, with the older flowers being situated towards the inside of the inflorescence, and the younger flowers towards the outside.

A **corymb** is a type of raceme with all its flowers held at the same level. The oldest flowers are positioned towards the outer edges of the inflorescence, the youngest flowers towards the centre.

A **spike** is another type of raceme, this time with stalkless flowers; foxglove (*Digitalis purpurea*) or mullein (*Verbascum thapsus*) are good examples.

Umbels are made up of many flower stalks of roughly equal length arising from the top of the stem. The term is easily remembered due to the similarity of the flower stalks to the spokes of an umbrella! **Compound umbels** occur when the stalks of an umbel in turn subdivide.

Whorls are created when groups of flowers, carried on stalks, are borne at intervals down the stem. A **thyrse** consists of an arrangement of two main flower stalks to each whorl; a **verticillaster** has four stalks per whorl.

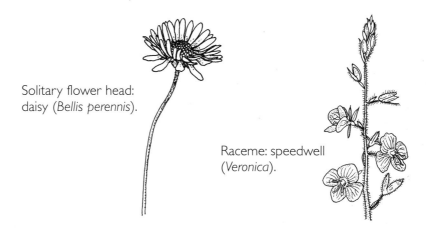

Solitary flower head: daisy (*Bellis perennis*).

Raceme: speedwell (*Veronica*).

Types of infloresence.

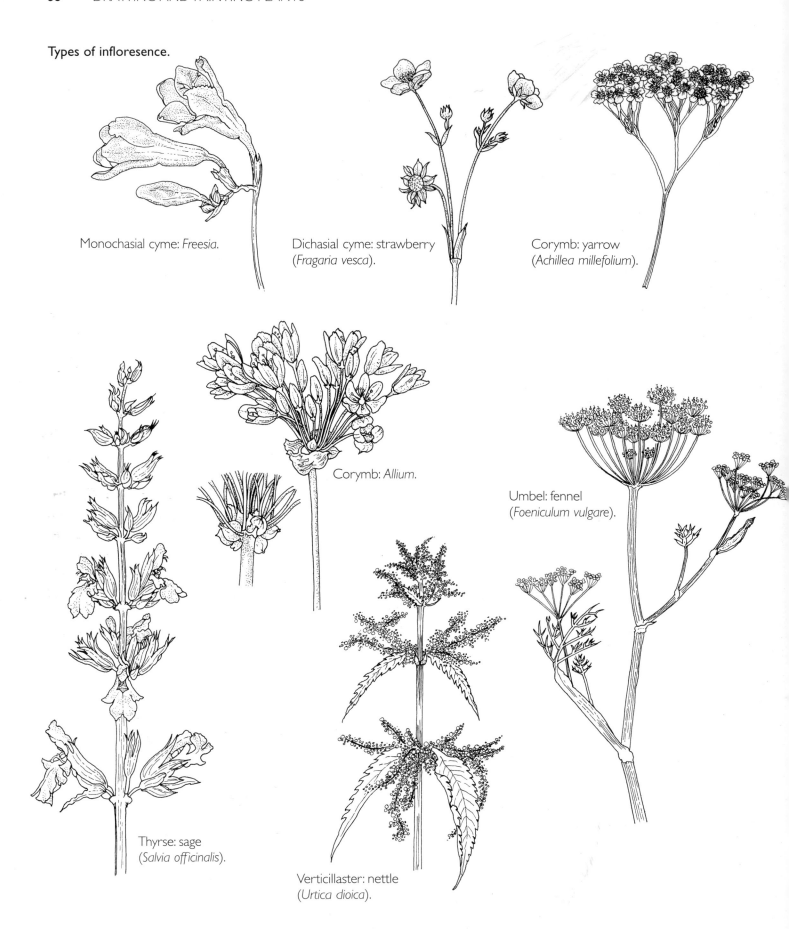

Monochasial cyme: *Freesia*.

Dichasial cyme: strawberry
(*Fragaria vesca*).

Corymb: yarrow
(*Achillea millefolium*).

Corymb: *Allium*.

Thyrse: sage
(*Salvia officinalis*).

Verticillaster: nettle
(*Urtica dioica*).

Umbel: fennel
(*Foeniculum vulgare*).

RIGHT Pin-eyed and thrum-eyed primroses.

Pollination

A flower can be **self-pollinated**, where pollen originates from the same flower, or **cross-pollinated**, where pollen originates from a different flower. Cross-pollination allows for more genetic variation, which can create more vigorous offspring because of the larger gene pool involved; it is thus taken to be more desirable.

The primrose has different flower structures to ensure cross-pollination. In the **pin-eyed** form, the stigma is situated above the anthers; this is the 'pinhead' seen on viewing the flower from above. In the **thrum-eyed** form, the anthers are situated above the stigma.

There are a number of differences between wind- and insect-pollinated flowers. **Wind-pollinated** flowers are often small and inconspicuous, such as those of grass flowers and catkins. They have no perfume or nectaries to attract insects and no brightly coloured petals; in fact, they may lack a corolla altogether. They produce copious amounts of wind-borne pollen.

Insect-pollinated flowers are usually large, conspicuous, perfumed and brightly coloured, with **nectaries**, structures that contain nectar as food for pollinators. Further signals to pollinators are provided by **honey guides** on the petals. These are spots, stripes and patterns on the flowers that guide pollinators towards the nectaries.

BELOW Honey guides in *Schizanthus*, pansy (*Viola*) and nasturtium (*Tropacolum*).

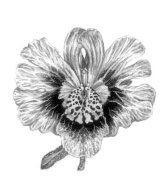
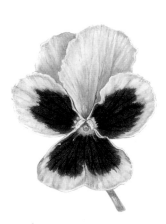

Fertilisation

When a flower is pollinated, cells contained within the pollen migrate down towards the ovary and fertilise the female cells through fusion. The fertilised cells respectively become the **embryo**, which is the immature plant, and the **endosperm**, which is the food store for the plant during the early stages of growth. The fertilised ovule containing the embryo and endosperm is called the **seed**.

Once the ovule has been fertilised, the flower withers, the petals are shed, and the ovary begins to develop into a fruit to carry the seeds. During this process, there are also a number of significant changes in the ovary tissues, notably those of the ovary wall's development into the outer layer or skin of the fruit, known as the **pericarp**; the outer layer of the ovule becoming the seed coat, or **testa**; and the fruit's gradual swelling and development into a receptacle for the seeds as they mature.

Fruits

The fruit is the part of a plant inside which the seed develops, and is the means for the seed's dispersal. Fruits have three distinct layers, or regions:

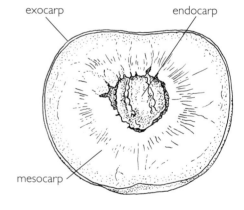

- The **exocarp** is the outer layer, and is often no tougher than a thin skin. The peel of a banana is an example of an exocarp.
- The **mesocarp** is the middle layer, and may be fleshy.
- The **endocarp** is the inner layer that surrounds the seed. Plums and cherries have a very hard, stony endocarp that surrounds the comparatively soft seed.

Parts of a fruit.

Some fruits, such as the apple, develop from the receptacle and not the ovary. The receptacle swells and grows up and around the ovary, enveloping it. Such a fruit is called a '**false fruit**' or **pseudocarp**, as opposed to a '**true fruit**', which develops from the ovary.

Sometimes a fruit develops without the need for pollination or production of viable seed, a process called **parthenocarpy**. This is true of commercially produced bananas, which are sterile hybrids.

Dehiscent fruits.

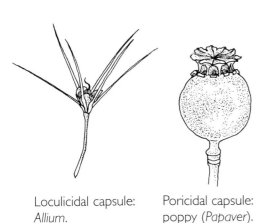

Loculicidal capsule: *Allium*.

Poricidal capsule: poppy (*Papaver*).

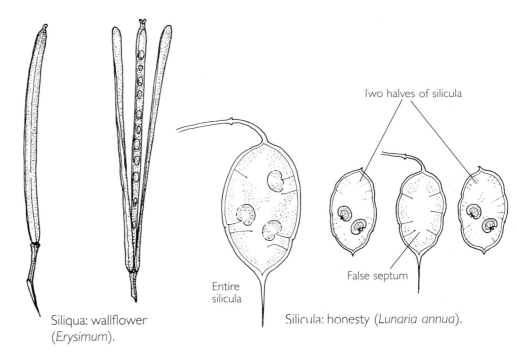

Siliqua: wallflower (*Erysimum*).

Two halves of silicula

Entire silicula

False septum

Silicula: honesty (*Lunaria annua*).

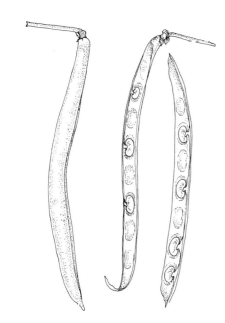

Pod: pea family (*Leguminosae*).

Different types of fruit

Dehiscent fruits are fruits that dry and then split open (dehisce) to release their seeds.

Indehiscent fruits are fleshy and do not split open. The seeds they contain are more likely to be dispersed via consumption by birds and animals.

Multiple fruits are fruits that have developed from many flowers, the ovaries of which have fused together.

Dehiscent fruits

A **capsule** is a dry fruit that may have one or more chambers and which either splits along several margins (**loculicidal**) or allows seed dispersal from its openings (**poricidal**).

The **siliqua** is a two-chambered fruit. It splits on both sides, from the base of the fruit upwards, to reveal a flattened central column, or **false septum**, to which the seeds are attached. If the siliqua's length-to-width ratio is 2:1 or less, it is termed a **silicula**.

Pods are typical of the pea family (Leguminosae). They open along both edges but, unlike the siliqua, have no central column; instead, the seeds are attached to both halves of the pod.

Indehiscent fruits

Nuts have a characteristically tough and woody exocarp as shown by the spiky outer coverings of beechmast and the cupules of acorns.

Indehiscent fruits.

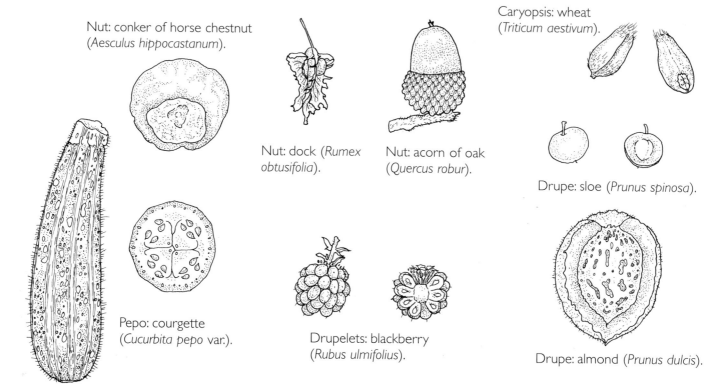

Nut: conker of horse chestnut
(*Aesculus hippocastanum*).

Nut: dock (*Rumex obtusifolia*).

Nut: acorn of oak
(*Quercus robur*).

Caryopsis: wheat
(*Triticum aestivum*).

Drupe: sloe (*Prunus spinosa*).

Pepo: courgette
(*Cucurbita pepo* var.).

Drupelets: blackberry
(*Rubus ulmifolius*).

Drupe: almond (*Prunus dulcis*).

A **caryopsis** is the fruit typical of the grass family. Here, the seed has become fused to the ovary wall. Again, the resulting structure is fairly tough.

Drupes are fleshy fruits with a hard stony endocarp surrounding a single seed. **Drupelets** are smaller versions of drupes, and often occur in clusters, such as in blackberries.

A **berry** is a fleshy fruit that contains many small seeds inside it: for example, the gooseberry or tomato. Our modern bananas are sterile hybrids, but, if fertile, they would also technically be considered berries!

The **pepo** is characteristic of the gourd family (Cucurbitaceae). This, too, is a berry.

The **hesperidium** has many chambers and a leathery endocarp. It is specific to citrus fruits.

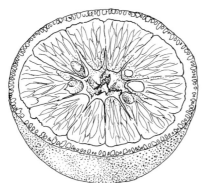

Hesperidium: orange
(*Citrus aurantium*).

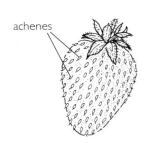
achenes

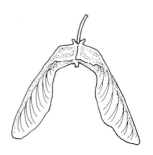

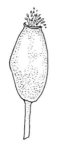
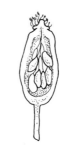

Cypsela: thistle
(*Cirsium vulgare*).

Achenes: strawberry
(*Fragaria vesca*).

Double samara: sycamore
(*Acer pseudoplatanus*).

Hip: rose (*Rosa cv.*).

Indehiscent fruits *continued.*

Achenes are small one-seeded dry fruits that may occur attached to an accompanying dispersal structure. One example is the **cypsela**, a typical flower of the daisy family (Asteraceae), where the achene is attached to the remains of the sepals. This acts as a parachute to transport the seed on the wind, and is called the **pappus**. Another example is the fruit of the strawberry. Technically, this is not a fruit at all, but is referred to as a 'false fruit', being derived from the receptacle, whose outer surface is studded with achenes.

Samaras are seeds with wings attached to aid their distribution; there may be one wing present (as with the ash tree), or two (as with the sycamore).

Hips and **pomes** are fruits typical of some members of the rose family. They are false fruits (pseudocarps) that carry seeds inside them.

A **cremocarp** is the fruit specific to **umbellifers**. As can be seen from the illustration, it consists of two halves which split apart when ripe to disperse the seed.

Pome: medlar (*Mespilus germanica*).

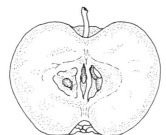

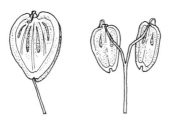

Pome: apple (*Malus cv.*).

Cremocarp: unnamed umbellifer.

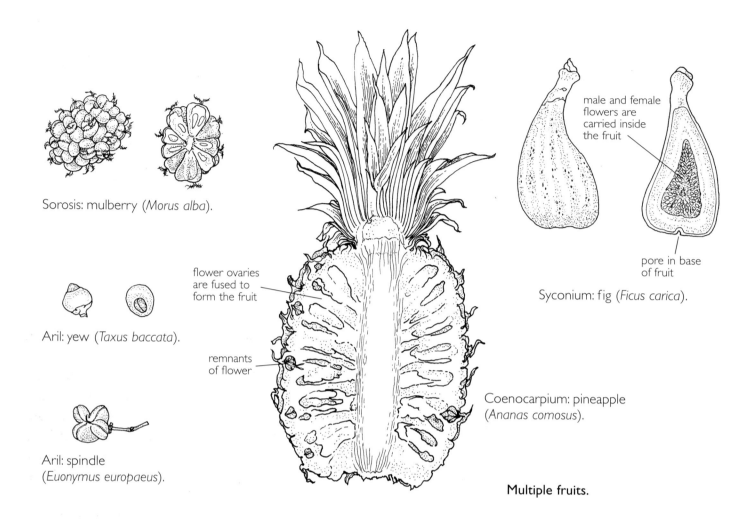

Sorosis: mulberry (*Morus alba*).

Aril: yew (*Taxus baccata*).

Aril: spindle
(*Euonymus europaeus*).

flower ovaries
are fused to
form the fruit

remnants
of flower

male and female
flowers are
carried inside
the fruit

pore in base
of fruit

Syconium: fig (*Ficus carica*).

Coenocarpium: pineapple
(*Ananas comosus*).

Multiple fruits.

Multiple fruits

The **sorosis** found in the mulberry develops from the fused ovaries of the many flowers carried on the inflorescence.

The **coenocarpium** of the pineapple consists of a semi-fleshy column carrying the matured, fused ovaries and receptacles of many flowers.

The **syconium** of a fig develops almost entirely from the receptacle, as a swelling at the end of a stem. Cutting a fig in half along its length will reveal that the tiny male and female flowers are actually carried inside the immature fig. Pollination is carried out in Mediterranean climates by the female European fig wasp, which crawls into a small hole at the end of the fig to lay her eggs inside the hollow fruit, making contact with the flowers as she does so. Northern European climates are out of this wasp's normal range, so in Britain fruit development is largely dependent upon parthenocarpy, and seeds are likely to be undeveloped.

Arils are spongy structures, outgrowths from the ovule that partly or wholly enclose the seed, as seen in yew, or spindle.

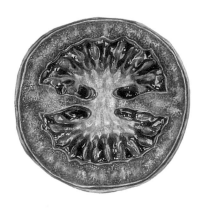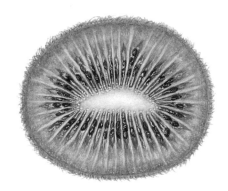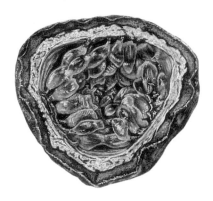

Sections through fruits: tomato (*Lycopersicon*); kiwifruit (*Actinidia chinensis*); passion fruit (*Passiflora*).

Painting fruits

Fruits are often easier to draw and paint than flowers as they have very definite, strong shapes and planes. Take account of their texture: the endocarp may either be rough and dull, hairy or spiny, or semi-reflective and smooth. A fleshy fruit that has been cut in half will be fairly moist and will show a very reflective surface in places. To paint this effect successfully, the base colours and detail should be painted prior to picking out the highlighted areas with white gouache. The highlights, whilst very bright, are unlikely to have sharp edges; either the brush may be moistened and the edge blended into the surrounding area, or the highlights should be built up slowly from a number of thinner layers so that they gradually 'fade in' from the base colour to the brightest areas of highlighting.

A section through a ripe fruit will also reveal the way in which the ovary is divided, for example, whether it is chambered, whether the seeds are attached to a central boss, or to the inner face of the endocarp.

Seeds and germination

As the seed develops, its cells differentiate to form the parts of the immature plant contained within it. These are the **plumule**, which will be the first shoot, the **radicle**, which will be the first root, and either one or two seed leaves, cotyledons. In some plants these appear above ground, in order to photosynthesise and produce food for the establishing seedling. In other plants, such as the pea or bean, the cotyledons may never appear above ground at all, but perform the function usually undertaken by the endosperm, that of providing a food store.

As the seed matures, it dries out considerably; this enables it to survive long periods of drought or cold conditions. A tiny hole, the **micropyle**, remains as a pore in the seed coat (testa), and will allow water and oxygen through when the seed is ready to germinate.

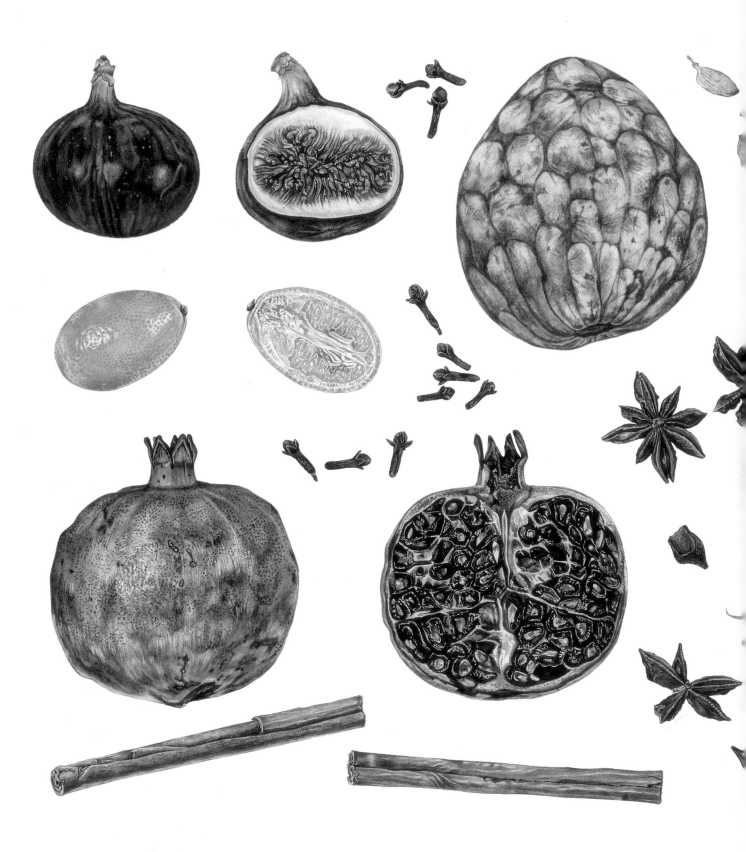

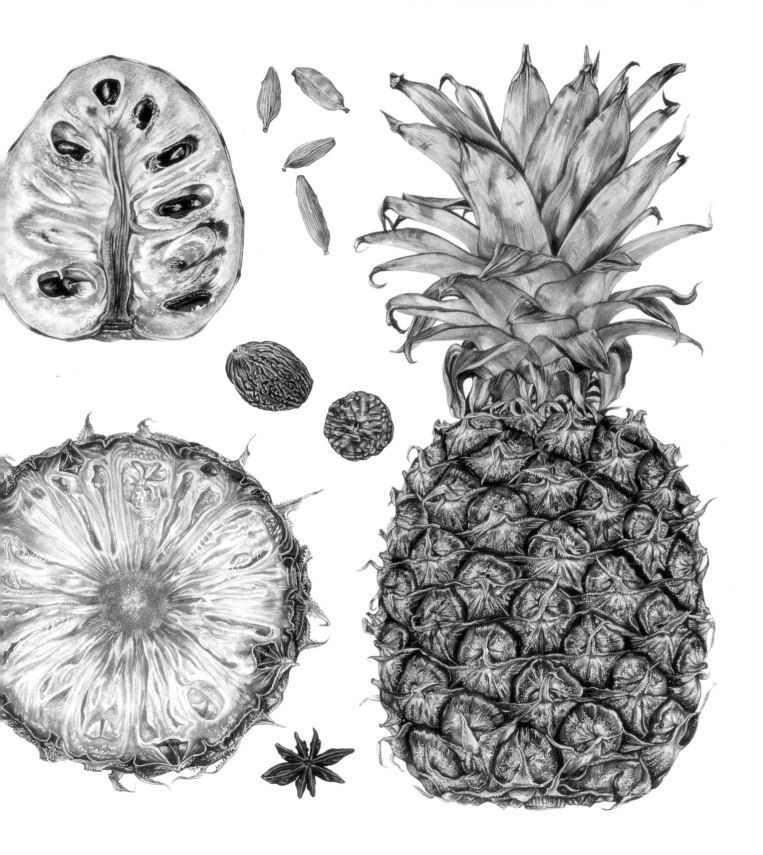

Tropical fruits and spices, CLOCKWISE FROM TOP LEFT
fig (*Ficus carica*), clove (*Eugenia caryophylla*), cherimoya
(*Anona cherimolia*), cardamom (*Elettaria cardamomum*),
nutmeg (*Myristica fragrans*), pineapple (*Ananas comosus*),
star anise (*Illicium verum*), cinnamon (*Cinnamomum zeylanicum*),
pomegranate (*Punica granatum*), kumquat (*Fortunella*).

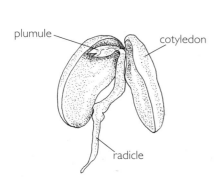

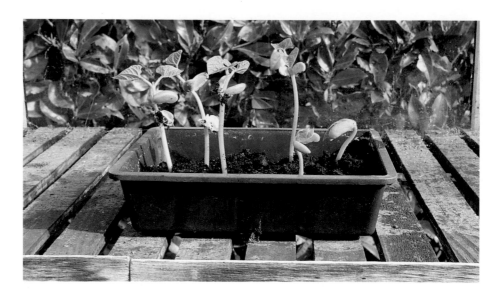

Germinating seedling of bean.
RIGHT Growing bean seedlings.

Germination

Germination occurs when water is imbibed through the micropyle and testa. As they take up water, the dry contents of the seed swell, so that the testa splits. Thus the plumule (first shoot) and radicle (first root) are able to emerge.

Grow seeds such as mustard and cress in a tray on a window sill, or germinate sunflower or bean seeds, and make a record of their development. By making a series of scaled drawings from the dry-seed stage, the seedling's growth can be charted.

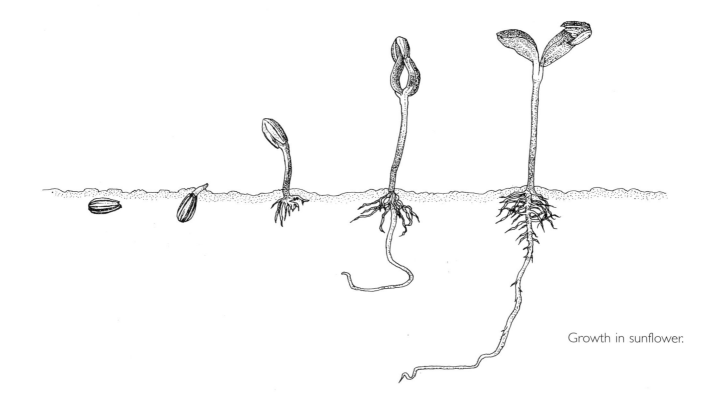

Growth in sunflower.

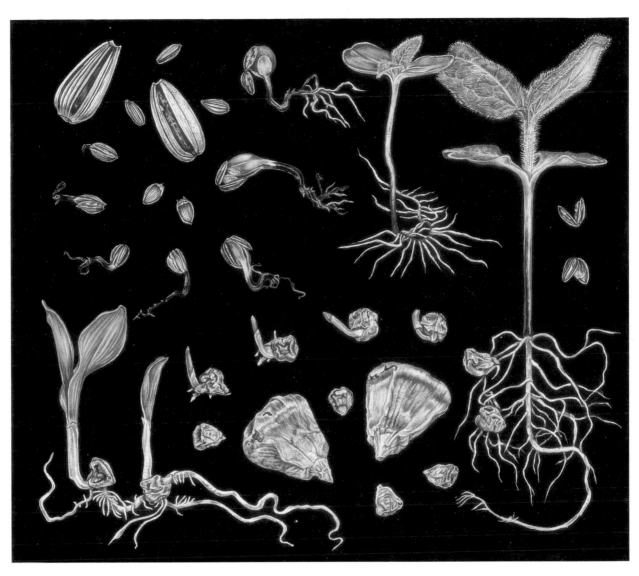

ABOVE Monocotyledon, dicotyledon: a study of seedling growth in sunflower (*Helianthus annuus*) and maize (*Zea mays*), showing magnified versions of the dry seeds alongside life-size depictions of the seedlings' development.

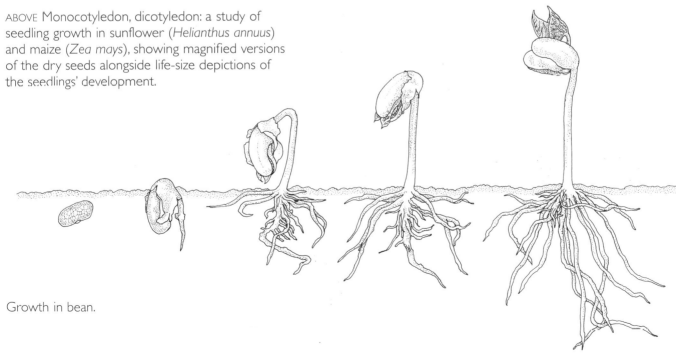

Growth in bean.

4 FLOWERING PLANTS:
Leaves, Stems & Roots

Leaves

Leaves perform photosynthesis, the process whereby absorbed energy from sunlight is used to convert oxygen, carbon dioxide and water, which permeate the leaf in their gaseous state, into food for the plant.

The flat surface of a leaf is called the **lamina**; its stalk is called a **petiole**. Leaves are either **simple**, with one leaf per main petiole, or **compound**, with many leaves per main petiole. Where the petiole meets the lamina, it branches repeatedly to form a network of veins that carry substances to and from the leaf.

Leaf shapes

Leaves take on a variety of different shapes; occasionally two different leaf shapes may be present in one plant, where the juvenile and adult leaves take dissimilar forms.

The descriptive terminology of leaves is usually easy to understand, deriving from Latin or Greek roots. For example:

Cordate = heart-shaped Deltoid = triangular
Reniform = kidney-shaped Sagittate = arrowhead-shaped
Spathulate = spoon-shaped Lanceolate = resembling the tip of a lance.
Rhomboid = diamond-shaped

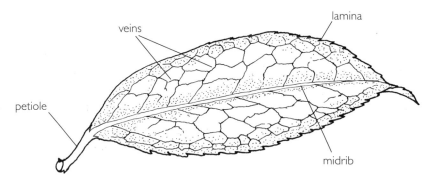

Leaf anatomy.

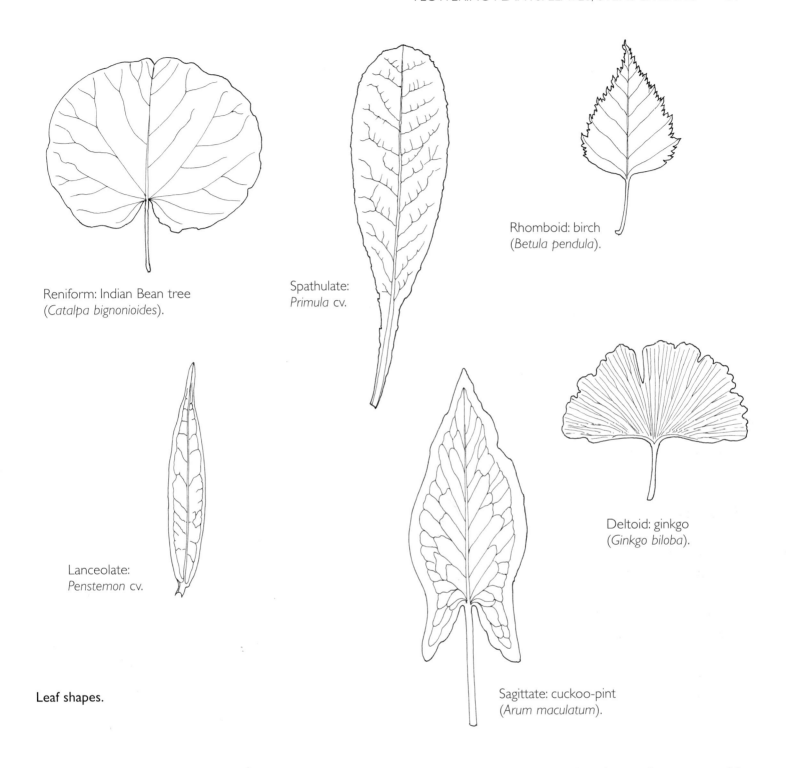

Reniform: Indian Bean tree
(*Catalpa bignonioides*).

Spathulate:
Primula cv.

Rhomboid: birch
(*Betula pendula*).

Lanceolate:
Penstemon cv.

Deltoid: ginkgo
(*Ginkgo biloba*).

Sagittate: cuckoo-pint
(*Arum maculatum*).

Leaf shapes.

Terms such as oblong, elliptic, ovate, oval, orbicular, or linear are self-explanatory. The prefix 'ob' before certain terms indicates that a shape has been inverted; examples of this are **obovate** or **oblanceolate**. The **runcinate** leaf form is typical of dandelions; the names reflects its ragged margin. Lobing may be present, as in oak leaves, which are **pinnately lobed**, and maple leaves, which are **palmately lobed**. A **peltate** leaf is one whose petiole terminates at its centre and not at one side.

Leaf shapes *continued.*

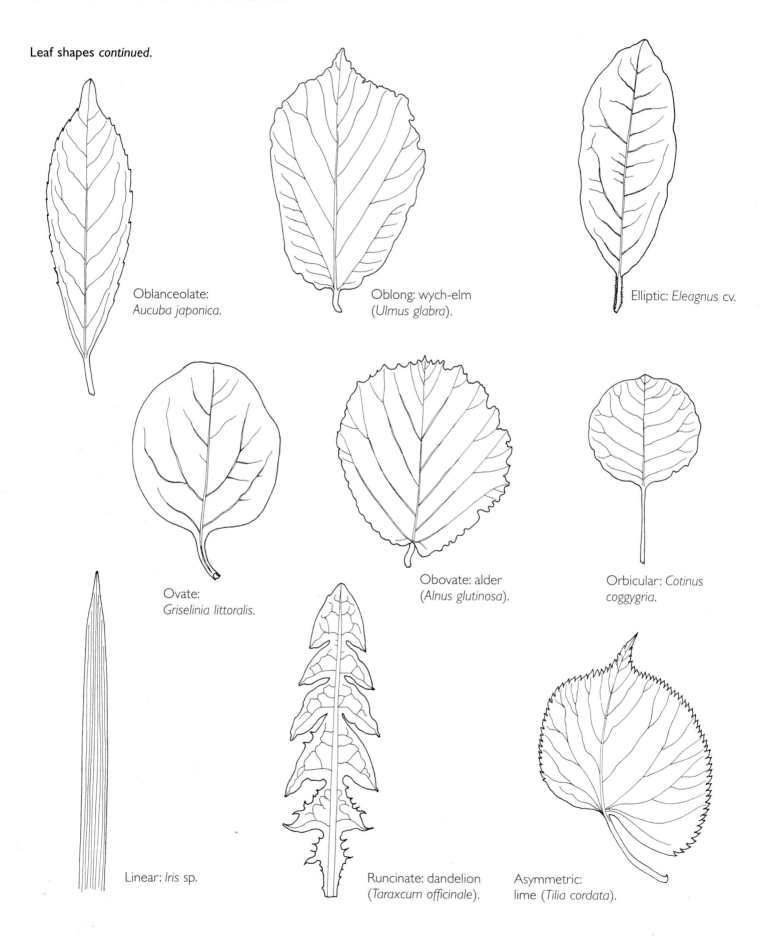

Oblanceolate: *Aucuba japonica*.

Oblong: wych-elm (*Ulmus glabra*).

Elliptic: *Eleagnus* cv.

Ovate: *Griselinia littoralis*.

Obovate: alder (*Alnus glutinosa*).

Orbicular: *Cotinus coggygria*.

Linear: *Iris* sp.

Runcinate: dandelion (*Taraxcum officinale*).

Asymmetric: lime (*Tilia cordata*).

Leaf shapes *continued.*

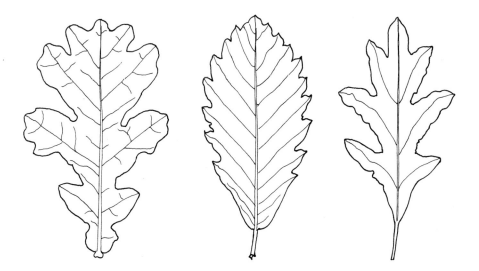

Pinnately lobed: oak (*Quercus*) species.

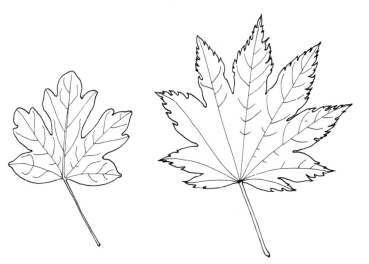

Palmately lobed: maple (*Acer*) species.

Peltate leaf, front and back views.

Compound leaves.

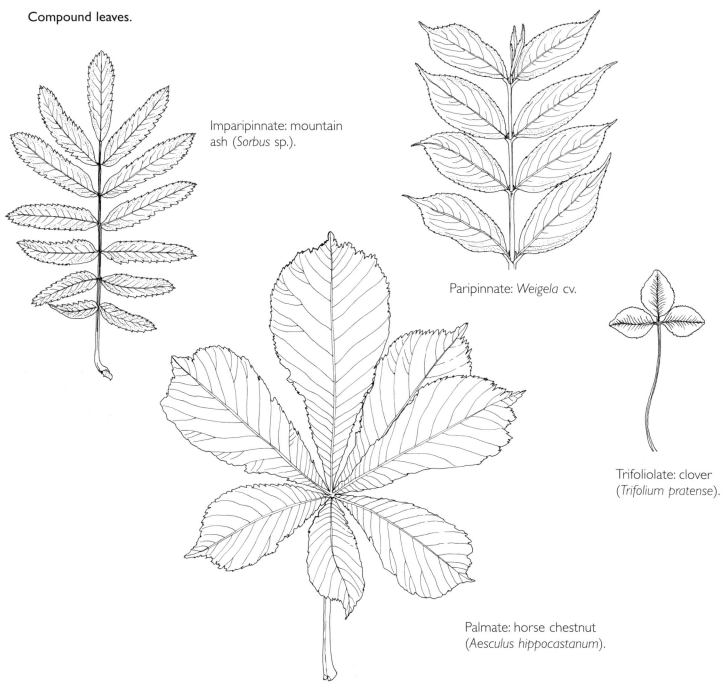

Imparipinnate: mountain ash (*Sorbus* sp.).

Paripinnate: *Weigela* cv.

Trifoliolate: clover (*Trifolium pratense*).

Palmate: horse chestnut (*Aesculus hippocastanum*).

Compound leaves refer to a group of leaves that were originally derived from a single leaf; their division into leaflets was an adaptation to water conservation. Terminology applied to compound leaves reflects their arrangement: the term **imparipinnate** refers to a petiole where pairs of leaflets are arranged opposite each other, terminating in a single leaf, whereas, in a **paripinnate** arrangement, the terminating leaf is absent; and **trifoliolate** arrangements are those in which leaves are carried in threes, whereas in **palmate** arrangements, the leaves' midribs radiate from the end of the petiole.

Leaf arrangements.

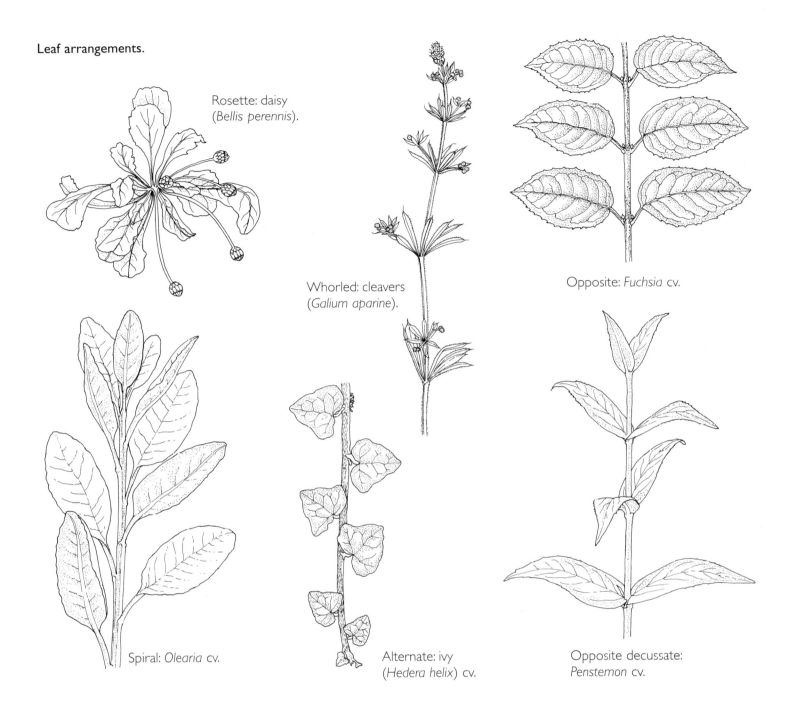

Rosette: daisy
(*Bellis perennis*).

Whorled: cleavers
(*Galium aparine*).

Opposite: *Fuchsia* cv.

Spiral: *Olearia* cv.

Alternate: ivy
(*Hedera helix*) cv.

Opposite decussate:
Penstemon cv.

Leaf arrangements

Leaves may be arranged up the stem in different ways. A **whorled** con-
figuration refers to the placement of leaves in rings, or whorls, around
the stem at different points. A **rosette** is a single whorl of leaves at the
base of the plant from which a flower-bearing stem arises. Leaves may
also be placed opposite each other (**opposite**), at right angles to one
another (**opposite decussate**), alternately up the stem (**alternate**), or in a
spiral formation (**spiral**).

The leaf edge is called a **margin**. **Entire** margins are those that show no undulation, incision or lobing. **Sinuate** margins show undulation of the margin in a horizontal plane, whereas **undulate** margins undulate in a vertical plane. **Serrate** margins are sharply toothed, like a saw blade, while **crenate** margins are similar to the edges of a shell. **Spinose** margins are heavily incised and tipped with spines.

Leaf margins.

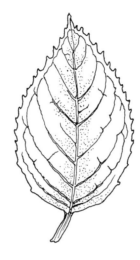

Entire.

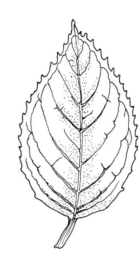

Serrate.

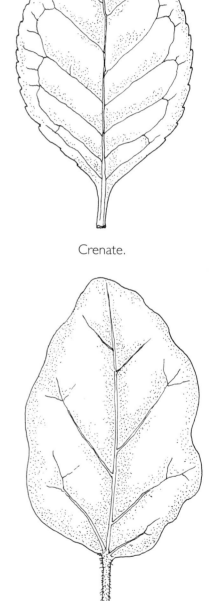

Crenate.

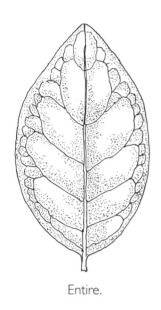

Spinose.

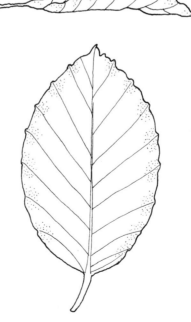

Undulate.

Sinuate.

RIGHT Bracts at the top, and base, of a lavender inflorescence.
FAR RIGHT Involucre at the base of a composite flower; stipule at the base of a petiole.

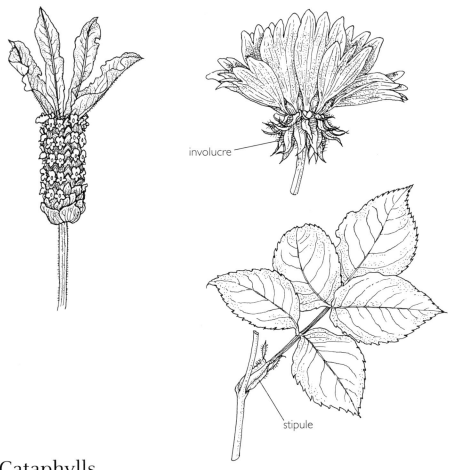

Cataphylls

Several leaflike structures may be present along the stem of the plant. These are called **cataphylls**, and are found either at the base of pedicels, where they are called **bracts**, or at the base of petioles, where they are known as **stipules**. Arrangements of bracts can be found directly underneath the petaloid florets of some members of the daisy family, such as thistles. The structure formed is called an **involucre**.

In grasses, the stem is enclosed by a white membranous structure called a **ligule**. The shape and size of this is used to identify different species of grass.

Painting leaves

The reflectivity of leaves should be considered, whether it be glossy, semi-matt, or with a faint, dull whitish bloom. A good way of accomplishing reflectivity is to work over highlighted areas in the base colour, then, picking out the highlights in white gouache, soften the edges as described in Chapter 3.

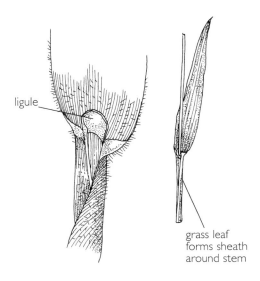

Ligule of grass.

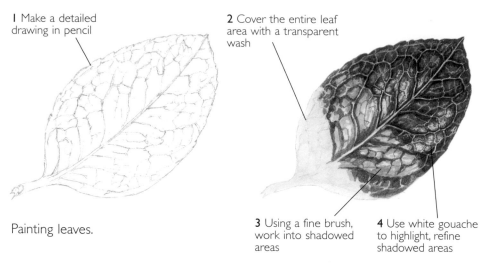

1 Make a detailed drawing in pencil

2 Cover the entire leaf area with a transparent wash

Painting leaves.

3 Using a fine brush, work into shadowed areas

4 Use white gouache to highlight, refine shadowed areas

Stems

Stems carry water and soluble compounds, such as mineral ions, sugars or proteins, from and to all parts of the plant, acting as a form of circulation system; the water-carrying networks and transport tissues within the plant are known as its **vascular** system.

Plants grow as a result of rapid cell division in areas of specialised tissue called **meristems**, which are mainly located at the tips of stems and roots. Meristems can also give rise to buds at the tips of stems (**terminal buds**) and along their length (**axillary** or **lateral buds**). These buds may develop into leaves and flowers. The point on the stem at which a leaf or lateral bud arises is called a node; the space between two nodes, an **internode**. **Lenticels** are a form of pore that allows gas exchange; they are situated along the length of the stem.

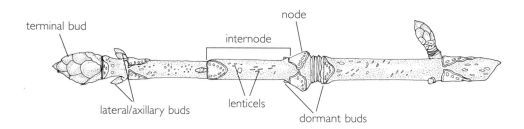

terminal bud

node

internode

lateral/axillary buds

lenticels

dormant buds

Roots and storage organs

LEFT Branch of horse chestnut (*Aesculus hippocastanum*).

Roots are responsible for the uptake of water and mineral salts, and are generally situated below ground. They frequently aid in spreading or sustaining plants; for example, the rhizomes of ground elder will allow it to spread profusely, and new bulbs (bulbils) are produced from older bulbs if these are allowed to overwinter underground. Roots and related structures can also become specialised for food storage.

Variegated leaves, including cultivars of ivy (*Hedera*); Hosta; zonal *Geranium*: *Pulmonaria*; *Cyclamen*; box (*Buxus sempervirens*); *Euonymus*; *Aucuba japonica*; *Thujopsis dolobrata*.

Types of root

Bulbs are not true roots but storage organs made up of swollen cataphylls. **Tunicated bulbs**, such as those of the onion, have a papery outer covering; **scaly bulbs**, such as those of the lily, lack this outer covering. The stem is much reduced, and found at the base of the bulb; the flower springs from the centre of the bulb.

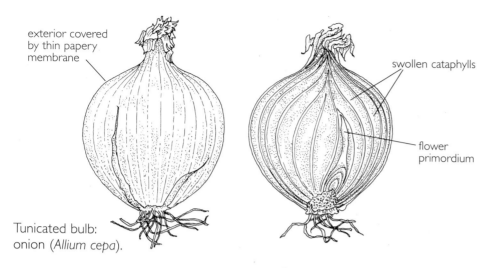

exterior covered
by thin papery
membrane

swollen cataphylls

flower
primordium

Tunicated bulb:
onion (*Allium cepa*).

Corms, like bulbs, are not true roots; they are a region of the stem that has swollen and which is used to store food. If corms are left in the ground, new corms will form on top of old corms the next year, being held in place with **contractile roots**. The flowering shoot emerges from the centre of the corm.

Rhizomes are underground stems from which shoots arise. They may branch, and are anchored by **adventitious roots**. Adventitious roots are not part of the main root system, but may help to spread and anchor the plant in unfamiliar places.

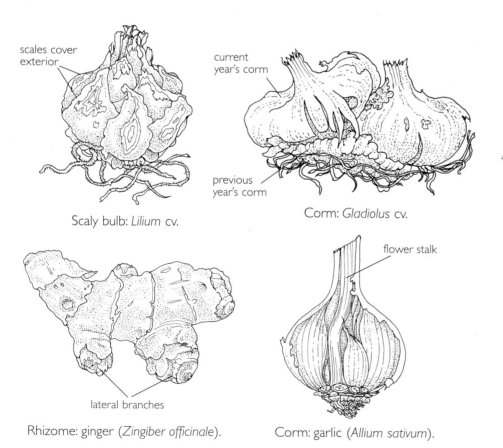

scales cover
exterior

Scaly bulb: *Lilium* cv.

current
year's corm

previous
year's corm

Corm: *Gladiolus* cv.

lateral branches

Rhizome: ginger (*Zingiber officinale*).

flower stalk

Corm: garlic (*Allium sativum*).

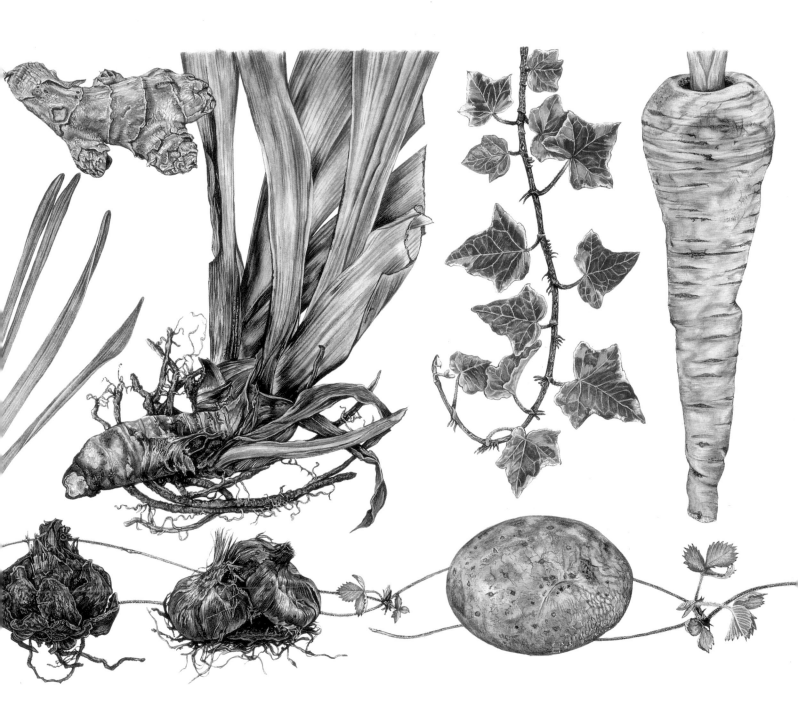

Different types of root, CLOCKWISE FROM TOP LEFT garlic (*Allium sativum*); daffodil (*Narcissus* cv.); ginger (*Zingiber officinale*); iris (*Iris* cv.); ivy (*Hedera* cv.); parsnip (*Pastinaca sativa*); wild strawberry (*Fragaria vesca*); potato (*Solanum tuberosum*); gladiolus (*Gladiolus* cv.); lily (*Lilium* cv.); onion (*Allium cepa*).

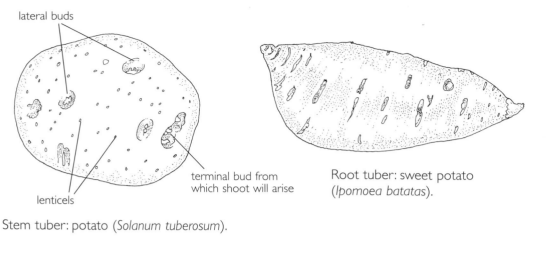

lateral buds

terminal bud from which shoot will arise

lenticels

Stem tuber: potato (*Solanum tuberosum*).

Root tuber: sweet potato (*Ipomoea batatas*).

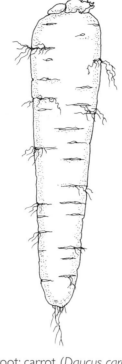

Taproot: carrot (*Daucus carota*).

Taproots are true roots that often take a globular or conical form. They probe deeply into the soil; one main root may give rise to several **lateral roots**.

Tubers are the swollen ends of rhizomes. They aid in food storage, and also in propagation of new plants. Stem tubers have lateral and terminal buds situated along them from which shoots can develop; root tubers, which resemble roots more closely, do not.

Stolons grow above ground and help to propagate the plant through the development of adventitious roots where the stolon comes into contact with the ground. However, they cannot be used for food storage.

Drawing the whole plant

Using the information set out thus far, it should be possible to make an informed painting of a whole plant. A typical botanical painting should incorporate flowers, fruits and/or seeds, foliage, stem and root if possible, at life-size or larger. Dissections may also be included.

Stolon: strawberry (*Fragaria vesca*)

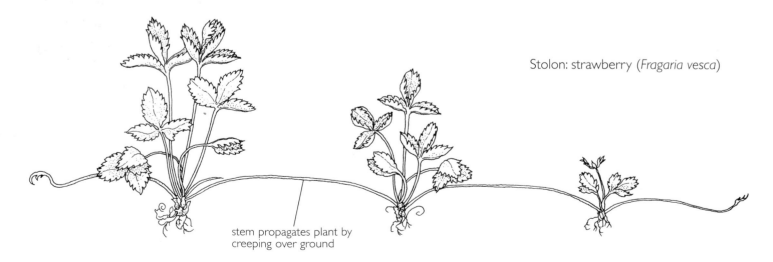

stem propagates plant by creeping over ground

5 MORE PAINTING MEDIA

Gouache

Gouache is essentially a thicker form of watercolour, but has a very different workability and appearance, since it is composed of greater quantities of pigment and binder. It can be thinned down and used as watercolour paints would be, but has the appearance of poster paint or screen-printing pigments when used in an undiluted state. If a wash of gouache is laid down next to a wash of watercolour, the differences between the two media, and most notably the greater opacity of gouache, can immediately be seen. An object painted in gouache has crisper edges and produces a 'silhouette' effect against the white of the paper; the colours are also more full-bodied and intense.

Since the paint is opaque, successive layers of colour have a tendency to cover one another, which produces an effect similar to a screen print. When painting with gouache, you will need to visualise your picture in exactly this way: as a succession of layers of different colours applied one on top of another.

Fine lines are more difficult to paint in gouache, since the paint has a thicker consistency. This may take a little while to become used to, particularly when using fine brushes, as the paint tends to clog the head of the brush; it is best to work with the tip of the brush, taking care to regulate the consistency of the paint. At all times, it is best to work with the inherent creamy, flat qualities of the paint, rather than against them. This holds true even if the gouache is considerably watered down.

Watercolour: less intense colours, softer outlines

Gouache: stronger colours, crisper outlines

The differences between watercolour and gouache.

A command of the gouache technique will be essential when portraying opaque or solid objects or surfaces, such as cones, coniferous and deciduous foliage, fruits, fungi, leaves and seeds. Colour intensity is much more quickly achieved, and the opacity of the paint can be regulated to accurately mimic textures and surfaces. In a more dilute form, gouache can also be used to depict flowers, although achieving a certain delicacy and luminosity is harder than with watercolour. Where relevant, I occasionally use gouache in combination with watercolour in my paintings to enhance the colour or brightness of certain areas where it is plain that the colour intensity of the watercolours I have used is insufficient. Spectrum Yellow, from the Daler-Rowney Designers' Gouache range, is a far brighter yellow than some comparable watercolours; I also use Permanent White for highlighting watercolour paintings.

The colours below approximate to the colours used for watercolour technique (see Chapter 2), though it is by no means necessary to purchase all these colours. I myself bought a standard six-colour box and augmented my range of colours by purchasing individual tubes from time to time and mixing watercolours with the gouache to achieve desired colours. Since both media are water-based, this is perfectly adequate.

Gouache colours, from Daler-Rowney's Designers' Gouache range:

Spectrum Yellow	Purple Lake	Prussian Blue
Cadmium Red	Spectrum Violet	Ultramarine
Rose Pink	Pine Green	Burnt Umber
Crimson	Fir Green	Permanent White

Make colour charts in order to assess how the colours behave when mixed with one another.

Gouache painting equipment.

Gouache painting technique

1 Draw the subject in detail, in pencil, on cartridge paper.

2 Lay the primary washes down with a larger brush in dilute gouache, so that the pencil lines are still visible.

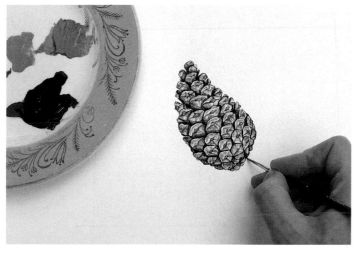

3 Deepen the base colour by laying down successively thicker washes of paint with finer brushes; work into shaded areas with the finer brush, and add highlights in Permanent White.

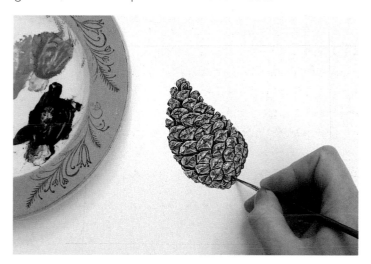

4 Rework the shadows and highlights to produce a crisp, finished painting.

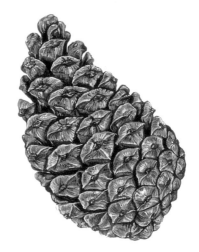

Pine cone.

Since gouache is very thick in consistency, I prefer to use acrylic brushes to lay down preliminary washes, rather than watercolour brushes. These should be synthetic and capable of withstanding much wear and tear; again, sizes 4, 7, and 2/0 brushes would be suitable. The brush used for fine detailing would, as for watercolour, be a synthetic, round watercolour brush of size 4/0.

The procedure is very similar to watercolour technique, though the difference in the consistency of the paint will be noticeable as washes are laid down. The opacity of the paint also enables mistakes to be covered more easily; light and dark colours can be overlaid if the paint is not made too wet.

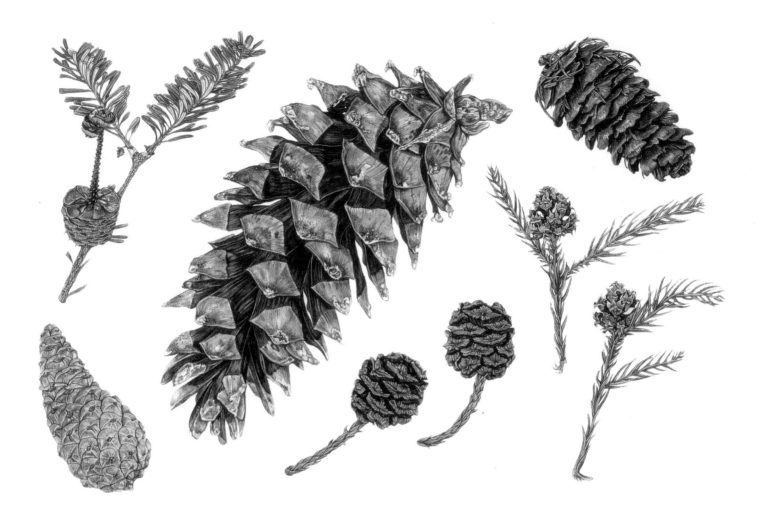

Acrylics

Acrylics are extremely versatile. They are composed of pigments mixed with a plastic binder; once dry, the paint will not shift. This enables one to lay down glazes, or thin washes, of paint over each other to produce glowing colours; or, conversely, the paint may be used in a less dilute form to produce a very solid, or opaque, effect. The concentration of pigment is greater than in watercolour, so less layering of washes is needed to achieve vibrancy of colour.

However, acrylic paint dries much more quickly than watercolour or gouache; thin washes may dry in a matter of seconds. It is necessary to work swiftly to lay down an even wash, using a sufficient quantity of paint and an appropriately sized brush. Detailed paintings may be completed within an extraordinarily short space of time; however, working wet-in-wet is not feasible. For this reason, it may take some time to become used to the qualities of acrylic.

The colours below are desirable; however, as with gouache, a basic palette can be built up from just six colours and the acrylic mixed with

Gouache painting of cones, including those of: fir (*Abies koreana*); a large-coned pine, possibly *Pinus coulteri*; Douglas fir (*Pseudotsuga menziesii*); cryptomeria (*Cryptomeria japonica*); sequoia (*Sequoiadendron giganteum*). This painting shows gouache's superior depth of colour and shadow in comparison to watercolour.

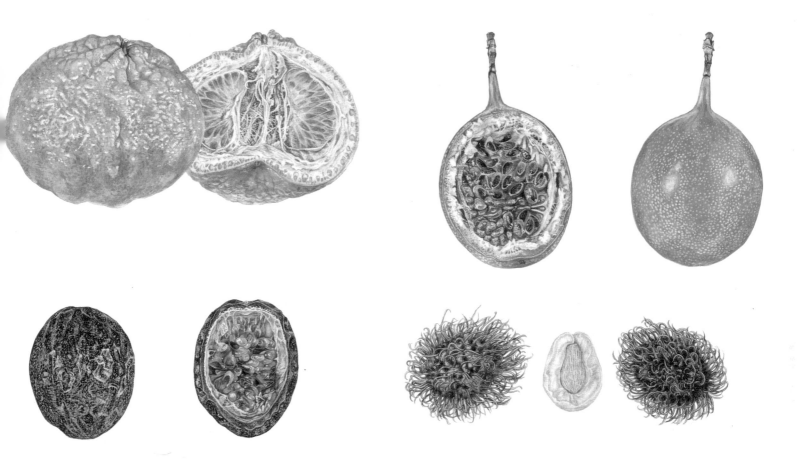

Tropical fruits, CLOCKWISE FROM TOP LEFT ugli fruit (*Citrus* sp.), granadilla, rambutan (*Nephelium lappaceum*), passion fruit (*Passiflora* sp.). This shows how acrylic can be used to create superb photorealistic and reflective effects.

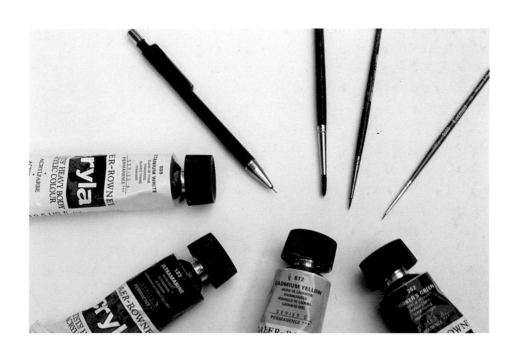

Acrylic painting equipment.

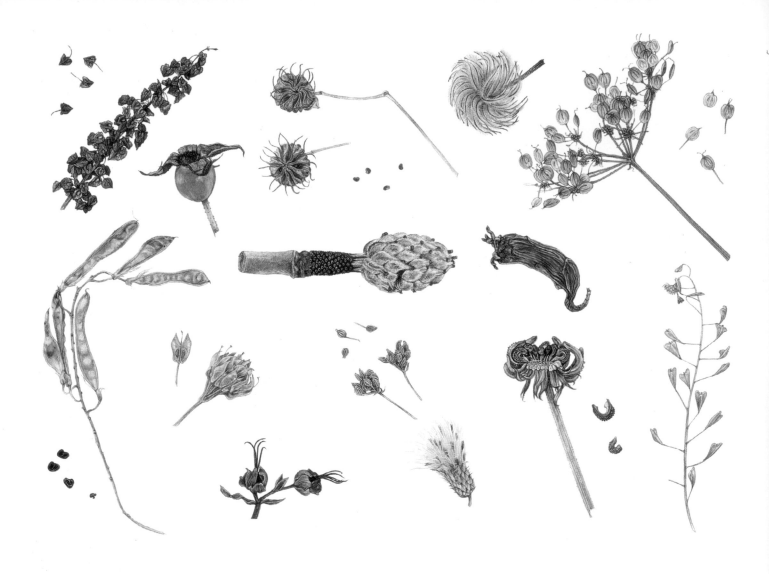

watercolour; the plastic binder will bind the watercolour in the same manner as it does the acrylic paint.

Acrylic colours, from Daler-Rowney's Cryla range:

Lemon Yellow	Crimson Alizarin (Hue)	Prussian Blue (Hue)
Cadmium Yellow	Quinacridone Violet	Ultramarine
Cadmium Red	Deep Violet	Burnt Umber
Permanent Rose	Hooker's Green	Titanium White

I have found that a glazed china saucer is superior to plastic palettes or tear-off palettes for mixing acrylic colours; the paint stays wetter for longer and is easier to remove once dry.

During painting, ensure that your acrylic brushes remain immersed in water; the paint will otherwise dry between the bristles of the brushes, and become very difficult to remove. Acrylics should only be used with acrylic brushes; they will ruin a watercolour brush. There is one exception to this rule: the fine synthetic watercolour brush may be used for shading

Dried seed heads, including members of the dock (Polygonaceae), carrot (Umbelliferaceae) and cabbage (Cruciferae) families; also *Clematis*; marigold (*Calendula*); wintersweet (*Chimonanthus praecox*); thistle (*Cirsium* sp.); *Magnolia*; St John's Wort (*Hypericum perforatum*). Note the soft textures of the magnolia and clematis seed heads, achieved by painting fine hairs in white over which a faint colour wash was laid.

Acrylic painting technique

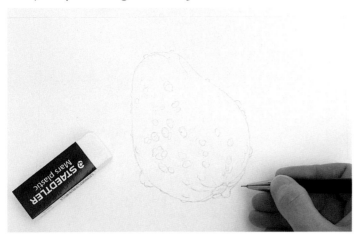

1 Draw the subject in detail, in pencil, on cartridge paper.

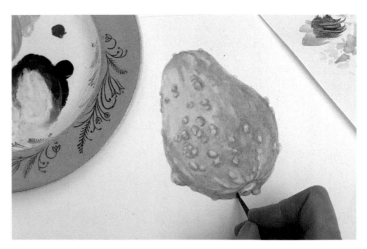

2 Lay down the main areas of colour and shade using variously sized brushes.

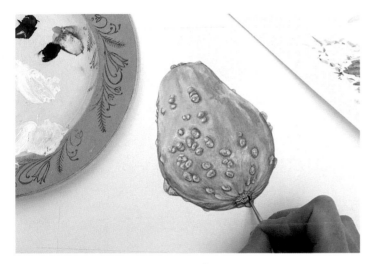

3 Pick out highlights in white acrylic.

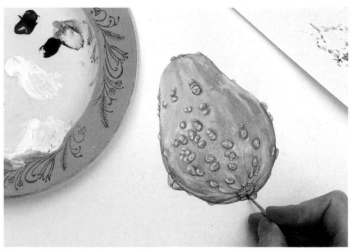

4 Rework the shadows with a fine brush to produce a crisply detailed painting.

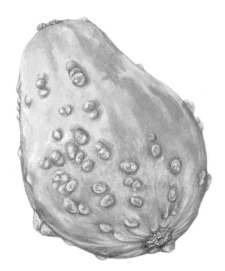

Squash.

and detail. It is good to keep several of these fine brushes to hand, and keep those used for each medium separate.

Acrylic can be used for translucent or opaque work alike, but performs best when used for solid objects such as fruits, seeds, cones, coniferous foliage and leaves. It has greater transparency, and produces a softer edge than gouache, but simultaneously retains opacity and colour intensity; therefore, it is an ideal medium for finely detailed and photorealistic effects.

To summarize, the same basic procedure of the laying down of washes and shading techniques is used as for watercolour and gouache. However, it is important to bear in mind the more rapid drying time of acrylic.

6 MONOCHROME DRAWING MEDIA

Pencil

Pencil can be used alongside the finished painting of a whole plant to create very simple outline drawings presenting different parts of the plant in greater detail. In this instance, the drawing would take the form of a detailed outline drawing of the same type that you would produce as the basis for a painting, and thus it would be unlikely to require further modelling.

However, pencil can also be used as a shading tool, to create monochrome drawings with a range of tones. When a simple outline drawing has been made, shadows may be filled in using a 2B drawing pencil worked in an elliptical motion. The drawing may then be further refined using the propelling pencil to sharpen fine details and deepen shadows; highlights may be picked out with a kneadable eraser.

Drawings done entirely in pencil have the disadvantage of smudging, and for this reason I prefer to use an underlying ink wash. This produces a crisper, smoother final result, and an effect similar to lithography. On occasion, I may also use watercolours underneath pencil.

Pencil with ink-wash drawing technique

In this technique, progressively darker washes of drawing ink are laid down over a detailed drawing until the required tonal balance has been achieved. The drawing is then refined, using the propelling pencil to work into shaded areas and define floral parts.

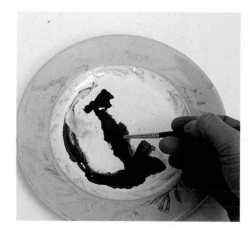

Mix up a wash of Rotring® ink to the required tonal value.

RIGHT Daffodils (*Narcissus* cvs.).

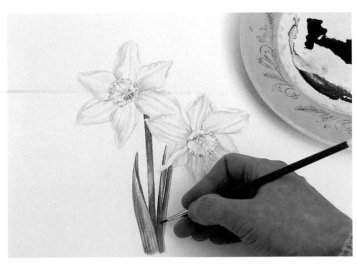

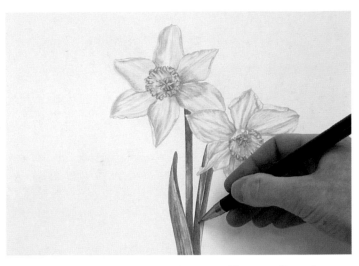

Work over a detailed pencil line drawing using ink washes of varying tonal values.

Work over the ink wash with the propelling pencil to deepen tones and sharpen details.

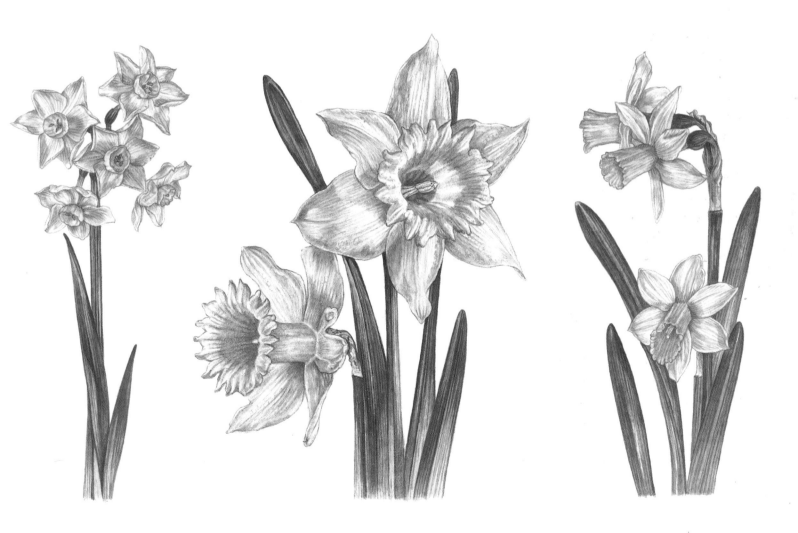

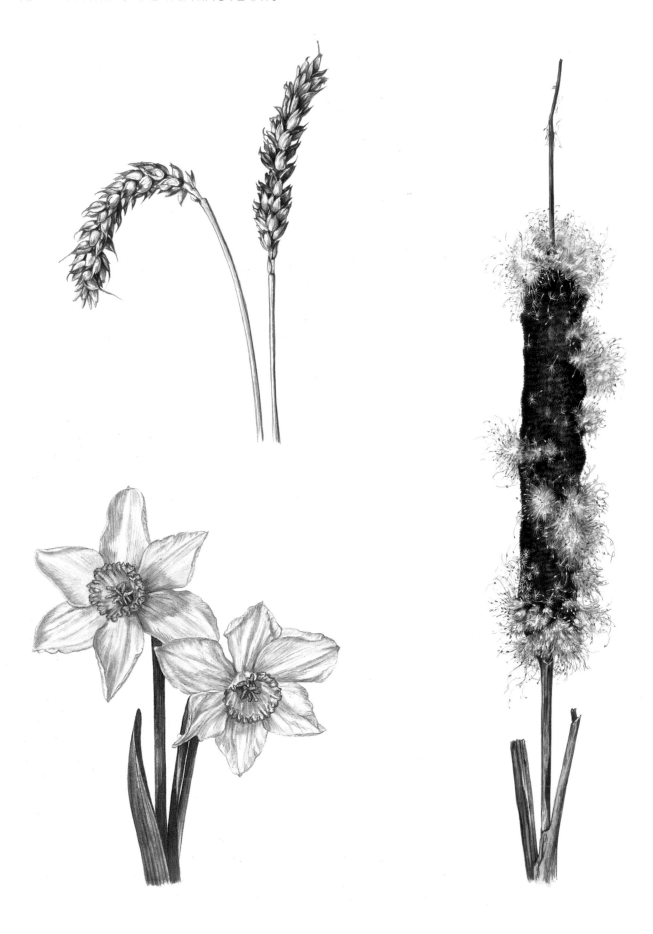

OPPOSITE LEFT, ABOVE Wheat (*Triticum aestivum*).
LEFT, BELOW *Narcissus* cv.
OPPOSITE, RIGHT Reedmace (*Typha latifolia*). Individual seedheads were picked out with white gouache against the dark pencil background.

Ink-drawing equipment.

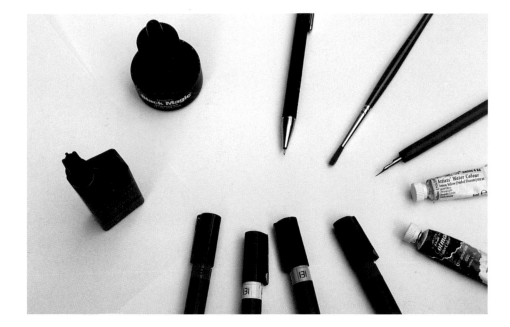

Ink drawings

Drawings in ink, whether executed with a dip pen or a technical-drawing pen such as a Rotring® pen, have a much more graphic appearance than drawings rendered in paint or pencil. You will find that you are less able to reproduce subtle tones and will therefore need to be more selective in representing the features of the subject.

Dip pen

Dip-pen drawings, as simple outline drawings in black or sepia ink, may act as a visual complement to a painting of a plant; or they may be celebrations of penmanship, detailed tonal drawings worked solely in pen and ink, with shading created from short, directional strokes.

For work done with a dip pen, a mapping pen should be used. Compare the line that it produces with that produced by technical-drawing pens such as those made by Rotring®. The line is of varying thickness, and thus invests a drawing with a more lyrical appearance, as opposed to a 'scientific' or 'technical' one. Use the pen with waterproof ink, which should preferably be acrylic-based; this will ensure that your drawing will not be spoiled by a chance water drop or any wet media. Ensure that all penwork is complete prior to tinting, and bear in mind that highly detailed drawings with large areas of dark shading do not colour well; a simple ink drawing with light shading to indicate the form of the subject will be more pleasing when coloured.

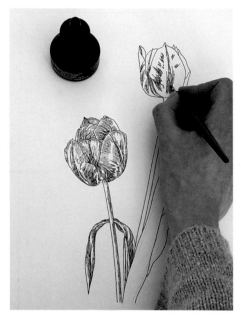

1 Make a detailed pencil drawing of the subject on cartridge paper.

2 Outline the subject before shading, using a continuous line to enclose all parts.

3 Shade the subject, using directional lines that blend into each other and follow the subject's contours; shade more densely in coloured or darker areas.

Dip-pen technique

In this technique, the mapping or dip pen is used to outline and shade a pencil drawing with directional lines following the contours of the subject, creating the effect of a woodcut engraving.

Before attempting a drawing with a dip pen, familiarise yourself with its ink-holding capacity. The pen should not be dipped in the ink all the way up to the penholder, or flooding will almost certainly result. Make a few strokes on a spare sheet of paper each time the pen is dipped, to eliminate any excess ink that may cause blots; do this in any case before you begin drawing, in order to familiarise yourself with the pen. When executing a pen stroke, aim to draw the pen across the paper towards you; do not push it away from you, as the nib may catch on the fibres of the paper and spatter the ink.

When outlining a drawing, ensure that all parts of the plant that are distinct are enclosed by a continuous line; this enables them to be seen as separate objects.

Technical drawing pens

These types of pen are used for technical and scientific illustration. They provide a line of uniform thickness, in contrast to the more lyrical line of varying thickness produced by a dip pen, and are available in a range of

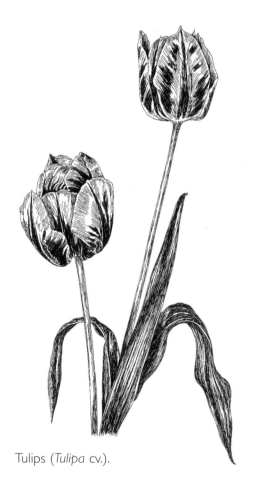

Tulips (*Tulipa* cv.).

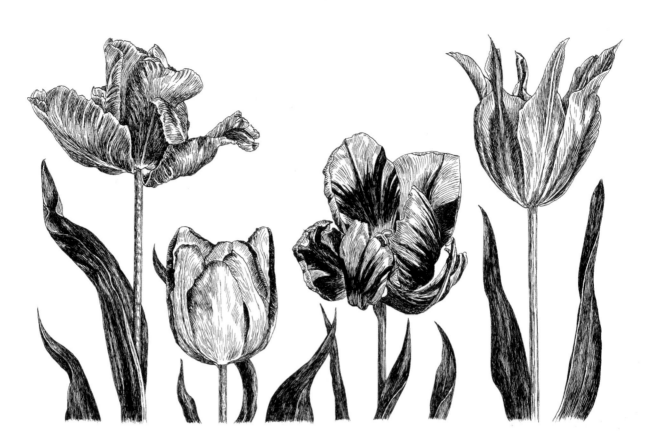

Row of parrot tulips.

different nib sizes. By using a stipple technique for shading, you can render extremely fine detail with them. Rotring® technical drawing pens can be refilled with Rotring® ink or cartridges. They will last for years, but are fairly expensive. However, cheaper disposable technical drawing pens are available in a series of thicknesses.

For this kind of penwork, the type of hot-pressed illustration board used for line-and-wash work is highly suitable. Copier paper can also be used for work that is intended for reproduction only; this weight of paper will not take wet media. You will also need at least two sizes of nib with which to render your drawing: a thicker (0.35 or 0.25) nib to outline, and a thinner (0.18) nib for the stipple shading.

Technical drawing pen technique

As with the dip pen, the different parts of the drawn subject should be outlined using a continuous line. The drawing may simply be left as an outline drawing, or it can be shaded using a stipple technique.

Shading should be done with the thinner nib, dotting lightly in the darkest areas of the drawing to build up the shadow in stages. Move gradually into the lighter areas before working back into the darker ones to intensify the shadows.

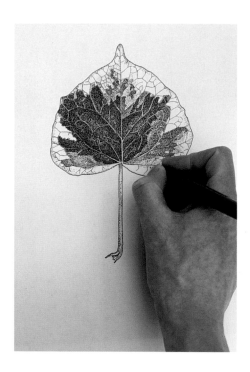

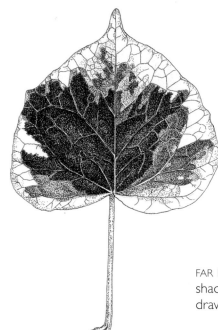

FAR LEFT Using stipple technique to shade a drawing rendered in technical drawing pen.

LEFT Ivy leaf.

The density of the shading may depend on the tone and colour of the object; if many colours are present, as in some flowers, these colours will need to be represented by different tones in order to differentiate them from one another. Shading density may, however, depend on the level of detail depicted; if only the form of the subject is shown, the density of shading may be minimal.

Tinting ink drawings

This technique can give the impression of a hand-tinted woodcut. It is best done with watercolours, prior to inking the drawing, as it cannot always be guaranteed that the ink used will be entirely waterproof. It is best to apply fairly intense colours and to keep to a minimum of shading; the shaded and coloured areas will otherwise compete with each other.

Scraperboard

Scraperboard can produce some wonderful effects similar to engraving, but is infinitely cheaper, quicker and easier to work with. It consists of a board covered with a china-clay preparation. The surface can then be covered with black ink, which is scraped off to produce an image. I prefer to make drawings from finished paintings rather than live subjects – transferring them to the board using chalked tracing paper – as

Tinted ink drawing: Flowers and fruit of hedge mustard (*Sisymbrium officinale*).

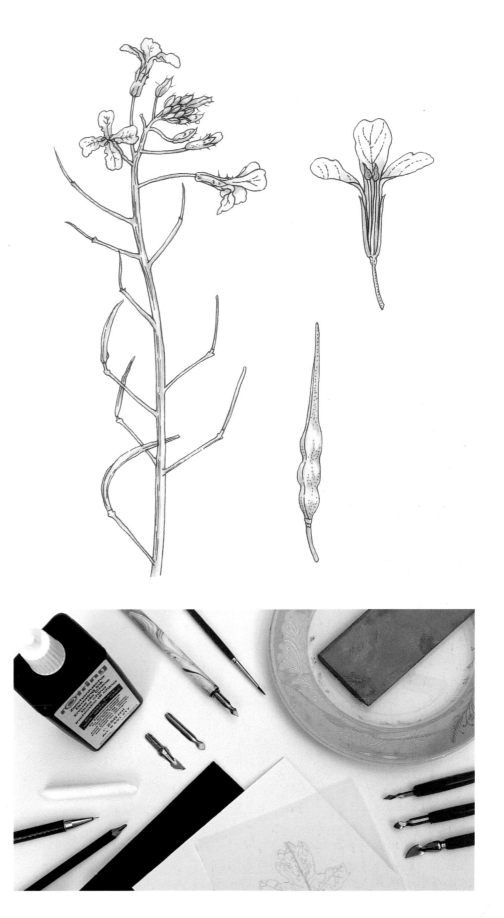

Scraperboard equipment.

White-scraperboard technique

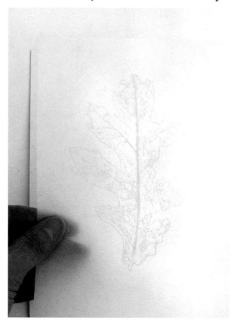

I Prepare a tracing of the drawing.

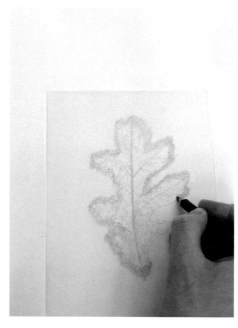

2 Rub over the back of the drawing using a 2B pencil.

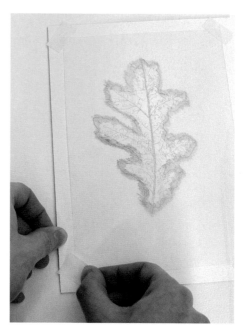

3 Place the drawing right side up on the white scraperboard and tape all of its four corners to the board using masking tape.

4 Trace just the outline of the drawing onto the scraperboard. Remove the tracing.

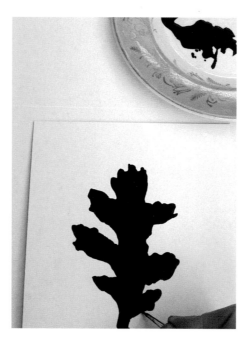

5 Fill in the shape using Rotring ink and a fine brush.

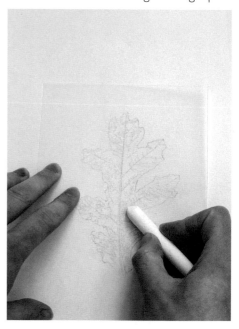

6 Erase the 2B pencil on the back of the traced drawing, then chalk the reverse of the tracing.

the tonal values are easier to control when working from a finished drawing. Black scraperboard comes ready-blacked; white scraperboard requires the form of the subject to be blacked in by the artist using drawing ink. It is vital to source good-quality, heavyweight scraperboard, such as Essdee Professional Grade scraperboard (see Suppliers).

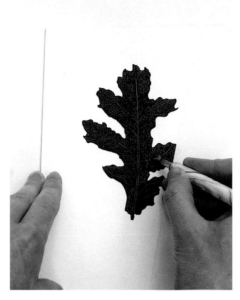

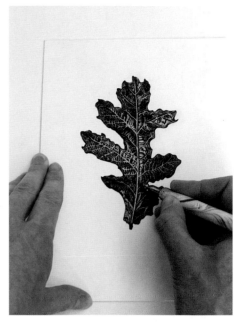

7 Tape the tracing to the board once more, in line with the outlines of the inked shape, in order to trace off details.

8 Following transfer of the traced details, and using a No. 1 scraper tool begin to excise the main lines of the shape following the chalk lines, plotting the principal veins first.

9 Using Nos. 1 and 2 scraper tools, excise the drawing using directional lines that blend into each other, working into highlighted areas to a greater degree.

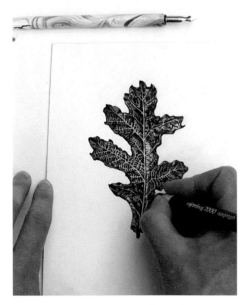

10 Work over the drawing using a Rotring® pen and ink and a No.1 scraper tool to refine it.

Note that the last five steps of this procedure should also be followed to create a drawing on black scraperboard; at the point of excision of any main lines, the outline should be drawn using a No.1 scraper tool.

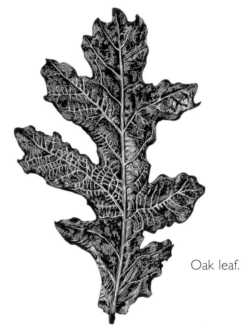

Oak leaf.

Much commercially available board is too thin, will not produce sufficiently fine lines, and will not allow for easy reworking.

There are four types of commercially available scraper cutter, conveniently numbered 1, 2, 3 and 4. These are sold either with their own holders, or loose, for use in any standard penholder. Each cutter produces its own type of characteristic mark or line. Nos 1 and 2 are those most often used to

Clematis: white scraperboard.

create fine scraperboard work. No.1 produces a very fine line, whereas No. 2 yields a slightly thicker line, or a wedge-shaped mark. No. 4 is useful for cleaning large areas; for example, the outline of a drawing on white scraperboard may be modified and defined using this tool. Experiment with the tools on a spare sheet of scraperboard before commencing drawing. Cutters should be periodically sharpened using a slipstone.

White scraperboard technique

This technique proceeds via the following steps: the outline of a drawing is transferred to the white board, the shape is infilled using ink, further detail is transferred to the shape, and the shape is excised using scraper tools. Rotring pens are then used to black out over-highlighted areas, and the shape may be further refined using the finer scraper tools.

When working on black scraperboard, a clean sheet of white A4 paper should be placed between the drawing hand and the board, to avoid transferring grease to the surface of the scraperboard. For this reason, it is also important to pick up any work by its edges.

ABOVE Pears: black scraperboard.
ABOVE RIGHT Maple leaf: white scraper-
board.
RIGHT Maple leaf: black scraperboard.

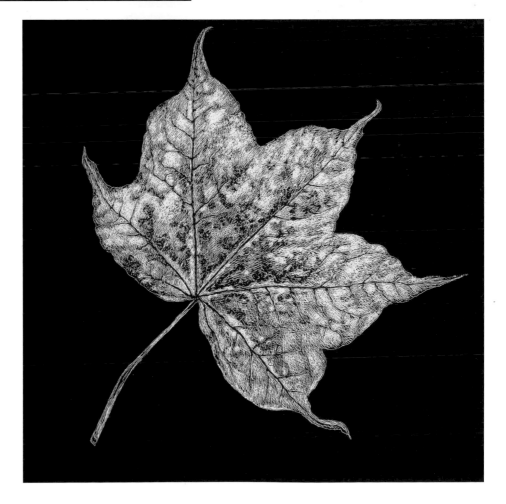

7 MEASURING AND MAGNIFYING PLANT PARTS

Measuring plants and drawing them to scale

Most people naturally paint plants at life-size, but sometimes you may wish to draw plants or plant parts at a larger or smaller scale. The situation is also likely to arise whereby you are requested to paint a subject to fit within a specific area or paper size. Compare the size of your subject with the size of your paper or drawing/painting area, and consider whether it would benefit from scaling up or down. A tree, viewed from several tens of metres away, would be impossible to draw at life-size on an A4 or A3 sheet of paper; likewise a microscopic object. The tree should therefore be drawn several hundred times smaller than life-size; the microscopic object, several hundred times greater.

Scaling up or down should be done by making an initial drawing of the subject, which should be as detailed as possible to make sure no information is lost or omitted. Horizontal and vertical measurements should then be made between specified points, with a ruler, scale or tape measure as appropriate. Sketch in the position of these dimensions on the detailed drawing, and write each measurement alongside or next to the line it relates to. Do not attempt to retain the measurements in your head!

Large and small objects: oak tree; daisy and pine pollen.

Description	Measurement	Multiplication factor	Result
Width of flower	3.00 cm	2	6.00 cm
Height of flower	2.40 cm	2	4.80 cm
Width of petal	0.90 cm	2	1.80 cm

Table of measurements.

Make a table of the measurements you have taken. The first column should contain a description of the measurement; the second, the value of the measurement itself; and the third, the multiplication factor. The third column will be filled when scaling calculations are performed.

Using a calculator if necessary, multiply the measurements by the amount the drawing is to be scaled up or down. For example, the measurements of a plant depicted at half its actual size should be multiplied by half; the measurements of a plant depicted at twice life-size should be multiplied by two.

Redraw the subject on a new sheet of paper. Using the original detailed drawing as a guide, draw a framework of dimension lines from which to construct the final drawing. However, draw the dimension lines using the new scale, so that the final drawing will be either smaller or larger than the original. Aim to ensure that all lines in the framework link up to form a 'skeleton' drawing from which you will be able to work easily. Once the dimension lines have been plotted, the subject's structure can be drawn in using the information from your original drawing. Some apparent distortion is usual with this technique; this is especially true of microscopic subjects. This is no cause for concern, as the final drawing, having been constructed from measurements, will be more likely to adhere to the correct proportions.

Making horizontal and vertical measurements is also useful when making a life-size drawing, and is invaluable in the correct execution of perspective drawing.

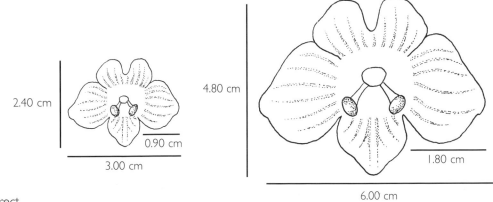

Scaling up an object to the correct proportions.

Using low magnification

There are a range of magnifiers and loupes on the market; the highest magnification available is usually about x10. They are useful for field-work, or for confirmation of the detail of structures only just large enough to be seen with the naked eye.

Plant parts and surfaces may be viewed in more detail using a binocular stereomicroscope or monocular light microscope, where the illumination from beneath is switched off and replaced by illumination of the subject from above or from the side using a flexible lamp. Binocular stereomicroscopes are suitable for low-magnification and three-dimensional work, but not plant sections. Light microscopes, lit from below, are able to accommodate slides of plant sections, and are more often used for high-magnification, transparent work.

For both types of microscope, subjects are viewed through the micro-scope **eyepiece**, which contains a magnifying lens. The subject is placed on a **stage**, and coarse and fine focusing knobs may be used to improve the view. For a supplier of loupes, microscopes and microscopic equip-ment please see the Appendix.

Several eyepieces of different strengths may be supplied with the light microscope; these are interchangeable, and fit into the top of the eyepiece tube, located at the top of the body tube. At the opposite end of the body tube is fixed a rotatable **nosepiece** with several different **objec-tives**. These also contain magnifying lenses of different strengths. The magnification of the eyepiece and objective together give the total **mag-nification**. For example, an eyepiece with x4 magnification combined with an objective of x5 would result in a total magnification of x20.

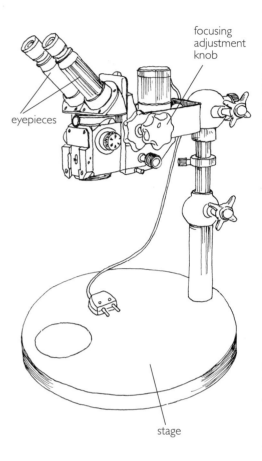

focusing adjustment knob

eyepieces

stage

A typical stereomicroscope.

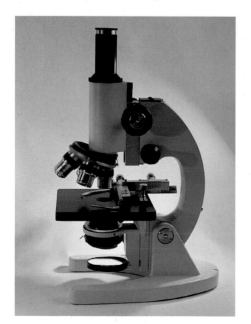
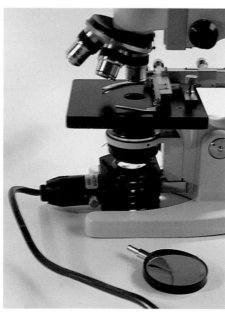

FROM LEFT Light microscope with interchangeable types of illumination from below: mirror and detachable microscope lamp.

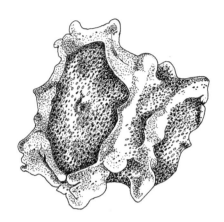

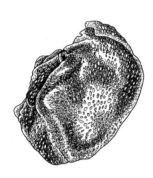

ABOVE, FROM LEFT Seeds of parsley (*Petroselinum crispum*), chard (*Crambe maritima*) and onion (*Allium cepa*) drawn at low magnification to reveal form and surface structure.

RIGHT Stained slides of botanical sections available from microscope suppliers.

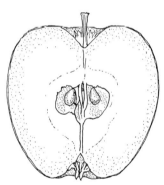

Longitudinal section (L.S.)

Transverse section (T.S.)

Examples of longitudinal and transverse sections of an apple.

Subjects are placed on a glass slide prior to being transferred to the stage. An illuminating mirror can be used in conjunction with natural light or with a spotlight to provide illumination for viewing thin sections or specimens. The mirror is often replaced by integral electric illumination.

It is difficult to obtain a clear picture of three-dimensional objects with stereomicroscopes above x200; operation is best within the x20–200 range. Nevertheless, even at low magnification it is surprising what can be revealed. The shapes of floral reproductive structures, seeds and hairs will often be unexpected; hairs on the surface of a lavender leaf, for instance, are shown to be star-shaped when viewed at x200.

Subjects observed at low magnification may be drawn or painted in any type of medium. Shading is essential when drawing or painting this type of subject matter, in order to reveal the three-dimensional structure.

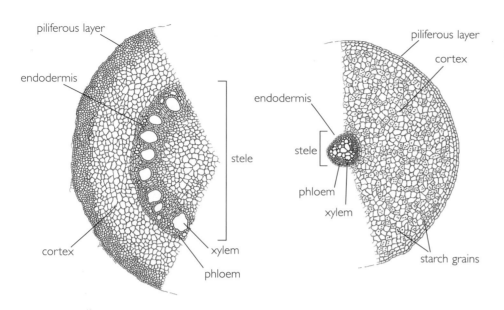

piliferous layer

endodermis

stele

cortex

xylem

phloem

piliferous layer

cortex

endodermis

stele

phloem

xylem

starch grains

Dicotyledon and monocotyledon stem sections.

Plant sections shown on microscope slides and viewed with the light microscope can aid your understanding of plant processes. Prepared slides of standard plant sections, of the types that are very commonly shown in school science textbooks, are available from microscope suppliers. Place the slide on the microscope stage, switching on the illumination from below. Initially use a low magnification, progressing to higher magnifications to obtain a view of smaller structures.

Sections of a plant part may be either L.S. (longitudinal section = section along the length) or a T.S. (transverse section = section across).

These sections can be annotated using textbooks; a botanical dictionary may also be necessary to clarify unfamiliar terms. They can also be created using a measuring eyepiece and stage micrometer to give more accurate proportions.

Using a stage micrometer

In the eyepiece tube of a light microscope, place a standard x10 **measuring eyepiece**, or eyepiece micrometer, on which is etched a scale; then place a **stage micrometer** on the stage. The stage micrometer is a specialist type of slide that also has a scale etched on its surface. This scale is 1 cm long and marked with 100 divisions. Therefore, 10 divisions will equal the length of 1 mm. The unit of measurement most often used in light microscopy is the micron, or micrometre, which is 1/1000th of 1 mm. If 10 divisions equal 1 mm, then 1 division will equal 100 micrometres.

The stage micrometer and a slide on which a subject is placed cannot be viewed at the same time, so the measuring eyepiece alone must be used when viewing actual specimens. However, since the scale on the

Measuring eyepiece and stage micrometer. Manipulate the stage micrometer so that both scales overlap. Count how many divisions of the eyepiece micrometer fit into 10 divisions of the stage micrometer.

measuring eyepiece, unlike that on the stage micrometer, appears a constant size regardless of the level of magnification, readings will need to be taken from the stage micrometer at different magnifications, in order to enable a measurement to be worked out from the measuring eyepiece. This is called **calibration**.

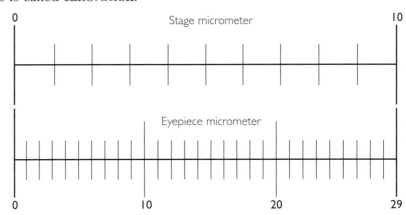

Chart showing number of divisions of eyepiece micrometer per 1 mm (1000 micrometres) of stage micrometer, at different magnifications.

Count the number of divisions on the measuring eyepiece that fit into 10 divisions (1 mm) of the stage micrometer. Make a note of this figure. Calibration will need to be undertaken for each magnification, since the figure will not be constant throughout. Record the figures in a chart for easy reference.

Magnification	40x	100x	400x
Stage micrometer	Imm (1000 micrometres)		
Measuring eyepiece (no. of divisions)	29	72.5	290 (29 divisions = 100 micrometres)

Values obtained from calibration at different magnifications. (N.B. This is an example only. Individual microscopes will need to be calibrated individually.)

At a chosen magnification, place a slide on the stage. Choose a dimension to measure, such as the length of a cell, and count the number of divisions. Call the figure Measurement 2, and compare this figure with

the figure obtained when previously calibrating the microscope at that magnification (Measurement 1). Divide Measurement 2 by Measurement 1, and multiply the answer by 1000 to obtain a figure for the dimension in micrometres.

Example:

$$\frac{125.0 \text{ (Measurement 2)}}{72.5 \text{ (Measurement 1}} \quad \text{x 1000} \quad = 1724 \text{ micrometres}$$
$$\text{calibration for x 100)} \qquad \qquad (1.724 \text{ mm})$$

Using the scaling method described earlier, make a detailed drawing of the subject annotated with actual measurements. Next, redraw the subject, scaling it up to a large enough size that it may be measured in centimetres rather than millimetres, and will therefore be a more comfortable drawing size. It will then be hundreds or even thousands of times larger than in real life.

Rendering of section drawings

Sections are two-, rather than three-, dimensional, and thus should be rendered using only different-sized Rotring® pens or other fine-pointed drawing materials, not paints. Although sections tend to be stained, some in two or three different colours, it is customary to represent them in black and white.

When rendering in technical drawing pen, draw in the main outlines using a thicker nib (0.35 or 0.25) before rendering detail using a finer nib (0.18). Since sections are two-dimensional, shading should be kept to a minimum.

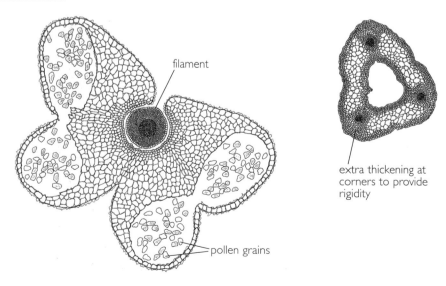

filament

pollen grains

extra thickening at corners to provide rigidity

Transverse sections through *Lilium* anther (left) and stigma (right).

8 TREES

Reproduction

Trees reproduce through setting seed either by means of flowers or cones. Flower-bearing trees belong to the flowering plant group, the Angiosperms, whereas cone-bearing species belong to the non-flowering Gymnosperms (see Chapter 1).

Flowering (angiosperm) trees

Many species of trees bear flowers that are either entirely male or entirely female (unisexual), rather than hermaphrodite (bisexual or 'perfect'). Flowers are often borne in groups on long inflorescences, such as the catkins of hazel (*Corylus*), or the panicle of horse chestnut (*Aesculus hippocastanum*).

Dioecious species bear male and female flowers on separate trees, as is the case with willow (*Salix*), holly (*Ilex*) and monkey puzzle (*Araucaria araucana*). If both male and female flowers are borne on the same tree, the species is termed **monoecious**. Some species are **trioecious**, such as the common ash (*Fraxinus excelsior*) and a few maple (*Acer*) species. The

FROM LEFT Flower of magnolia (Magnolia), catkins of alder (*Alnus glutinosa*) and birch (*Betula pendula*), and pine cone. Observe the similarity between the spirally arranged floral parts of the magnolia, the arrangement of the individual flowers on a catkin, and cone scales.

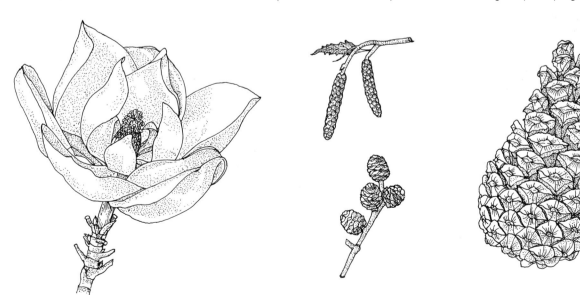

flowers of these trees may be either male, female or hermaphrodite, and trees may be either dioecious or monoecious. Moreover, on any one tree the combinations may be entirely random from year to year.

Most catkin-bearing trees – where the flowers are small and inconspicuous, lack petals and produce large amounts of pollen – are wind-pollinated. The catkins often appear before the leaves in order to increase the likelihood of pollination; the presence of leaves might otherwise hinder the pollen from reaching its destination. Trees with larger, more showy flowers, like magnolias or apples (*Malus*), rely more on insect pollination.

Recording tree shapes and bark

In conventional textbook illustrations, a single branch of a tree showing flowers/catkins/cones, foliage, fruits/seeds and/or autumn colour is depicted alongside a drawing or painting of the whole tree.

A sketchbook or camera may be used for recording tree shapes and bark textures in the field; it is perfectly acceptable to work from photographs, particularly when weather conditions do not permit sketching or time is limited. Ensure that the photograph is well lit, in focus and contains enough information for you to make a good painting. Deciduous trees in leaf are best photographed lit from the front; bare trees in winter, lit from behind. To give some estimation of the tree's height, it may also be useful to include a person in your photograph.

Trees may be rendered in pencil, ink or paint. When using paint media, it is best to choose gouache or acrylic rather than watercolour, as this gives more solidity and conviction to the painting. The tree should be placed against a white background so that the shape can be more easily appreciated, with a swathe of ground or a shadow painted underneath.

When painting deciduous trees in winter, very carefully and lightly indicate the branches in a darker brown or grey using a fine brush as seen on page 98. Do not use very straight strokes for branches, as this looks unnatural; tree branches or trunks are very rarely perfectly straight in appearance, with the exception of some conifers.

In winter, when trees are bare, the type of bark enables the tree to be easily recognised even from a distance. It is best recorded by means of photography, as portraying its considerable intricacies and texture in the field can be time-consuming. A section of bark can then be incorporated into the painting alongside the tree shape. Take some time to appreciate the qualities of different barks, such as those of certain conifers (*Pinus, Sequoiadendron*), cherry (*Prunus*), birch (*Betula*), oak (*Quercus*), and maple (*Acer*).

Coniferous and deciduous trees painted and drawn from photographs, rendered in paint, ink and pencil.

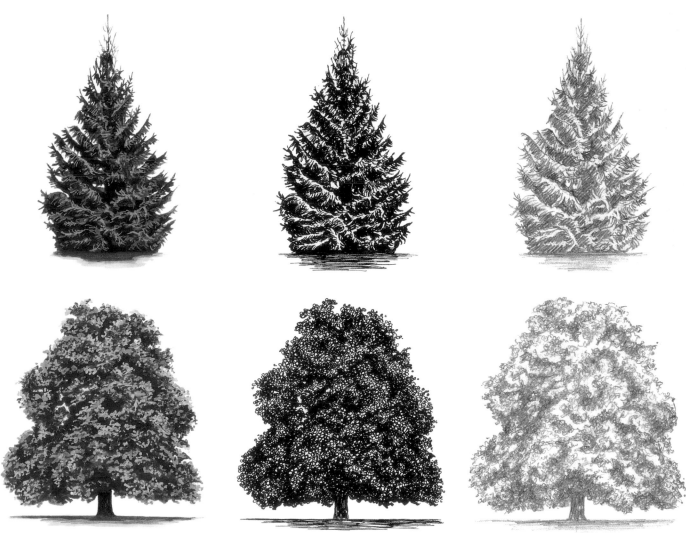

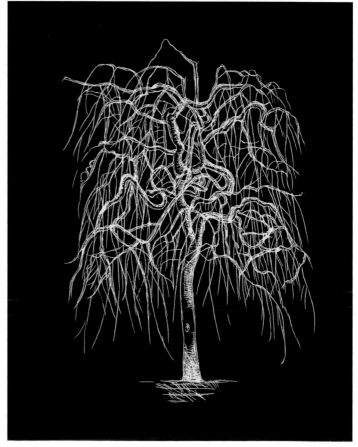

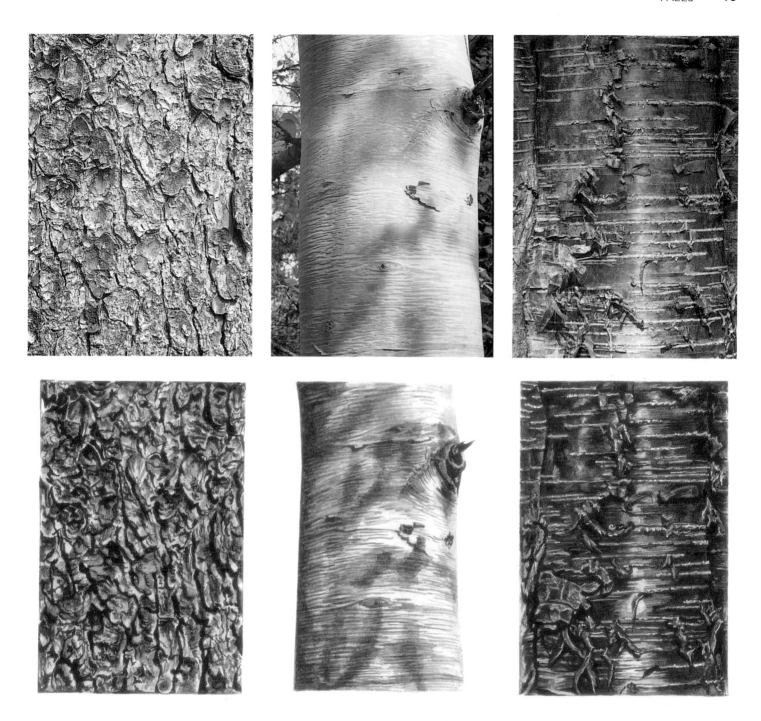

Paintings made from photographs of bark taken in the field.

OPPOSITE White or black scraperboard can also be an effective medium, especially for deciduous trees in winter.

Catkins, winter twigs and buds, autumn colour

Both male and female catkins should be shown, since they are very different in appearance and thus an important diagnostic feature. It is likely that the oppositely sexed catkins will ripen at different times; this is to ensure cross-pollination between trees and promote variety within the gene pool. The tree may therefore need to be inspected regularly over several weeks after the ripening of the first catkins.

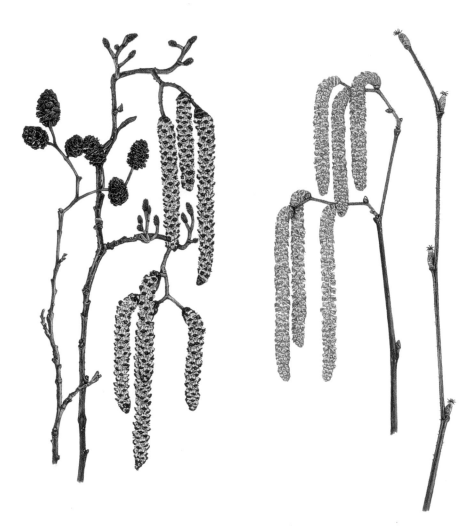

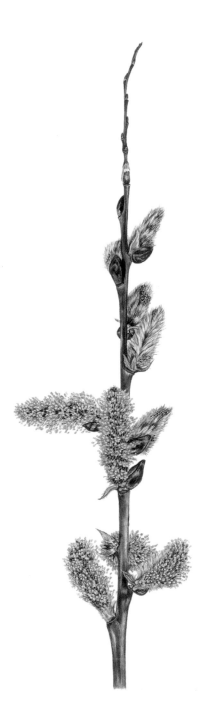

LEFT Male (pendulous) and female alder (*Alnus glutinosa*) and hazel (*Corylus avellana*) catkins; note how each scale is carefully delineated.

Since catkins are extremely intricate and detailed inflorescences, they are best portrayed using acrylics to achieve a realistic effect; this gives a solidity, but also a delicacy, to the painting. Where possible, you should aim to delineate every scale of the inflorescence to give the painting an accurate and realistic appearance.

Winter twigs and buds often have specific shapes or colours, according to tree species; together with the bark, they can also serve as diagnostic features. For example, the large, sticky buds of horse chestnut (*Aesculus hippocastanum*) are easily recognisable, as are the colourful, oppositely branching twigs of various dogwood (*Cornus*) species.

The leaves of many trees turn a distinctive yellow, orange, red or purple colour in autumn or winter. The constituents of chlorophyll, the green photosynthetic pigment in the leaves, are reabsorbed by the tree to conserve them as photosynthesis decreases due to lower light levels. Other pigments, called **accessory pigments**, which are also present in the leaf, are preferentially revealed. The constituents of these pigments are more expendable than those of chlorophyll, and it does not matter if they are lost by the tree. Thus, the autumn colour of a tree signals its preparation for a stage of dormancy.

Goat willow (*Salix caprea*) catkins; the qualities of acrylic enable the fine hairs and each pollen-covered anther to be accurately rendered.

Winter buds: FROM TOP horse chestnut
(*Aesculus hippocastanum*), walnut
(*Juglans nigra*), ash (*Fraxinus excelsior*),
beech (*Fagus sylvatica*), oak (*Quercus
robur*).

Winter twigs: FROM TOP willow (*Salix*),
decorative bramble (*Rubus*), and three
twigs of different dogwood (*Cornus*)
cultivars.

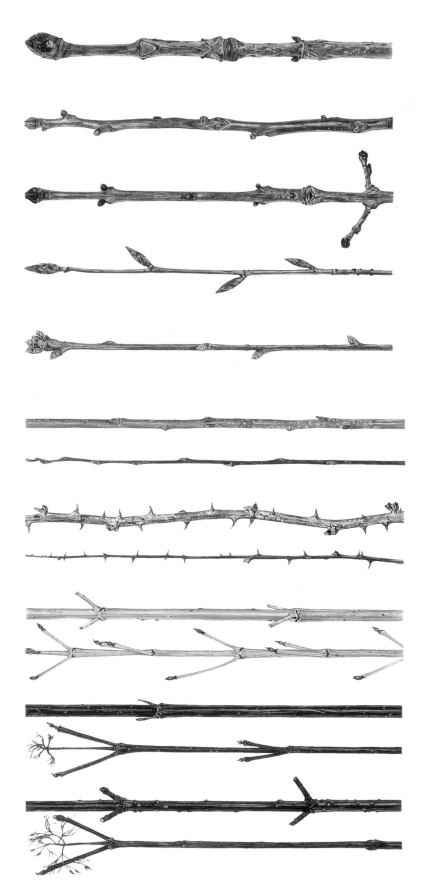

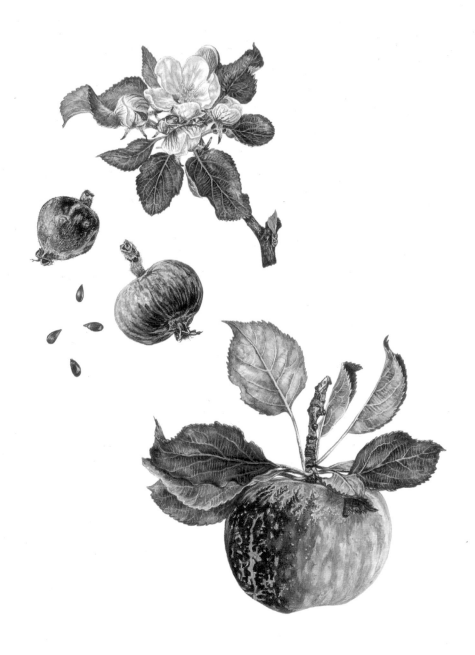

LEFT Apple (*Malus*) 'Discovery', showing hermaphrodite flowers (painted earlier in the year) alongside fruit in various stages of development, and seeds.

RIGHT The wonderful autumn and spring colours of Japanese maples at Westonbirt Arboretum, Gloucestershire.

BELOW Autumn colours of various leaves from Westonbirt Arboretum, including plane (*Platanus orientalis*); oak (*Quercus palustris*); sweet chestnut (*Castanea sativa*); three types of maple (*Acer platanoides, A. rubrum, A. palmatum* cv.); katsura (*Cercidiphyllum japonicum*); ginkgo (*Ginkgo biloba*); beech (*Fagus sylvatica*) and birch (*Betula pendula*).

Cone-bearing (gymnosperm) trees

These bear their seeds in cones rather than ovaries; the technical term 'gymnosperm', translating as 'naked seed', reflects the fact that the seeds are not wholly surrounded by the protective tissue of a fruit, but are instead liable to be exposed to the air as cones open and close in response to weather patterns.

The concept of cones is not dissimilar to that of male and female catkins. Copious amounts of pollen are transferred from the male to the female cone by wind in the same way as for male and female catkins. It may be that catkin-bearing trees, many of which come from temperate

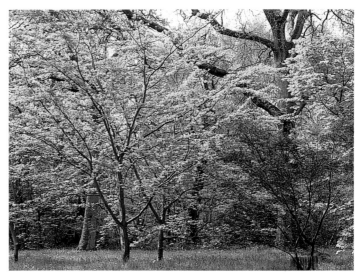
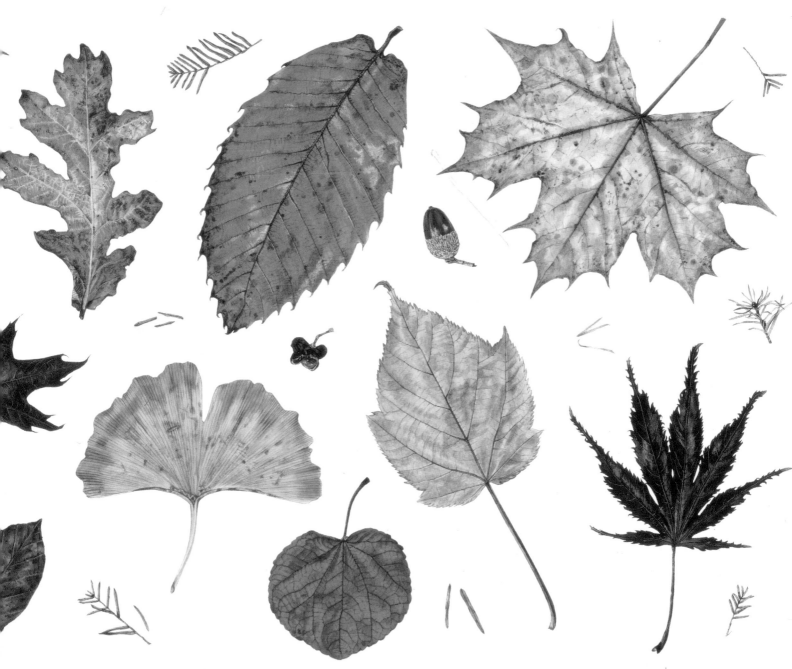

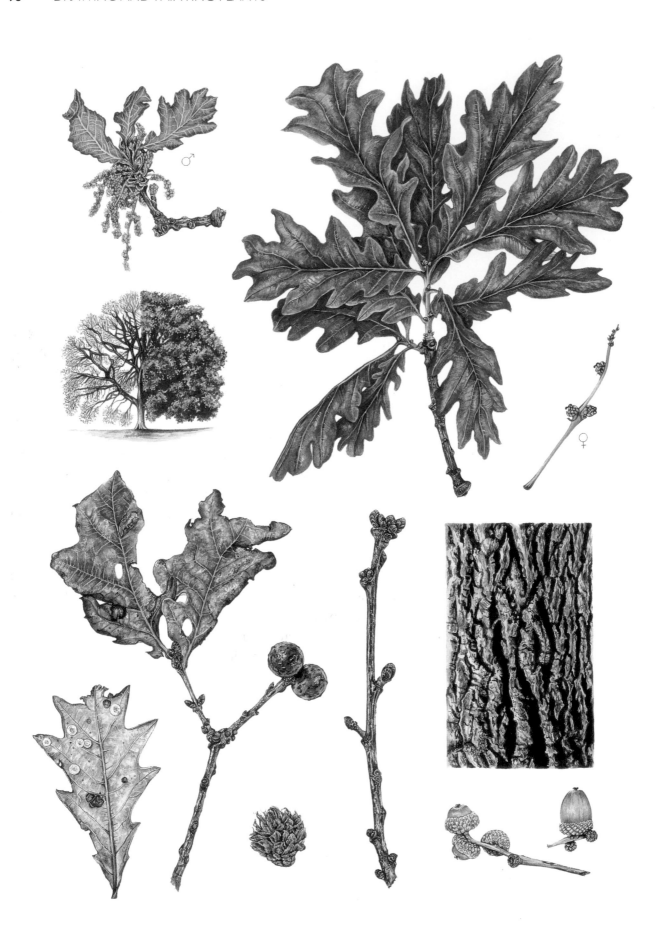

OPPOSITE Oak (*Quercus robur*), showing clockwise from mid-left: tree in winter and summer; male catkins; branch in leaf; female catkins; bark; acorns in various stages of development; winter twig; a selection of galls.

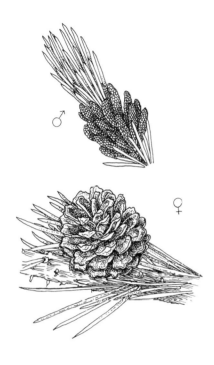

Male and female cones of *Pinus* sp.

climates, evolved in preference to trees with showier flowers simply because they, like the gymnosperms, were more successful in inhospitable or windy environments where few insect pollinators were available.

Trees are mainly monoecious, with separate male and female cones borne on the same tree. Male cones bearing pollen usually arise from the terminal bud at the end of a branch. Two sacs containing pollen are borne on the lower surface of each of their scales, to enable the pollen to be released freely. When the pollen is ripe, the cone dehisces (dries out and opens). The scales separate and each of the pollen sacs splits. The pollen is dispersed by wind. In pine (*Pinus*) pollen, each pollen grain has wings attached in order to enable it to travel on the wind.

Female cones arise from slightly behind the shoot apex. Two ovules are borne on the upper surface of each scale, to ensure that pollen is caught and trapped easily. Pollination occurs in early summer when the scales of the female cone open. Wind-borne pollen grains pass between the scales of the female cone, and a drop of fluid is secreted by each ovule to trap the pollen and improve the chances of fertilisation. Actual fertilisation may take up to a year to reach completion.

The fertilised ova develop into winged seeds on the upper surface of each of the female cone's scales. The shape of the wing is different according to species; compare a seed from a fir (*Abies*) cone to that of a cedar (*Cedrus*) cone. Seeds are shed mainly during dry weather when the scales are open, usually in the summer following pollination. In some species of pine (*Pinus*), the length of time elapsing between development of the female cone and seed dispersal may be up to three years.

Some conifers may appear to have slightly unusual reproductive structures. In juniper (*Juniperus*), the 'cones' are fleshy; this is caused by the fusion of the cone's scales. Yews (*Taxus*) do not bear cones as such, but rather a single ovule surrounded by a fleshy aril when ripe, resembling a berry; the yews are difficult to classify botanically and are conventionally grouped together with conifers.

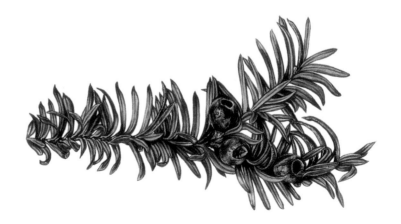

RIGHT Yew (*Taxus baccata*) with seeds enclosed by arils, rather than cones.

Using coniferous foliage and cones to identify coniferous species

Many conifers have needle-like leaves; these have waxy coats and, compared to a broadleaved tree, a reduced surface area per leaf. They are also carried in dense bunches, which increases the overall surface area. All these factors reduce moisture loss in harsh, windy or arid conditions.

Some conifers have scale-like leaves that cover the whole stem; these are called scale-leaved conifers. Juvenile leaves may be needle-like. The more primitive groups of conifers, such as redwoods, may have awl-shaped or compound pinnate leaves. The length of the leaves, and the ways in which they are grouped, in addition to the shape of the cone, can be used to tell different types of coniferous trees apart.

Painting coniferous foliage

It is not necessary to paint an entire branch of coniferous foliage; the end of a branch that includes a cone or cones is sufficient. You will, however, need to indicate and delineate each leaf that you draw. For scale-leaved conifers, a magnifying-glass will almost certainly be needed. The opaque qualities of the cone and foliage surfaces make gouache or acrylic the most suitable media.

In pencil, block in the part of the coniferous branch that you want to draw, using lines to mark the positions of the main and lateral shoots. Then sketch in guidelines to mark the positions of each leaf positioned along the shoots before using them to draw the leaf shapes in detail. Sketch in and draw the foreground leaves before drawing the leaves behind them; that way, any confusion over the placement of leaves will be substantially reduced!

Mix up the local colour (midtones) of your foliage in the chosen medium and, using a fine brush, apply it over the entire drawing in a fairly thin wash so that pencil lines are still visible. This will act as a base for subsequent layers of paint. Next, mix up a darker, more opaque wash and apply it to shaded areas.

Refine the areas by applying a small amount of white over the top of the colour, which will create a waxy or reflective texture. Rework the coloured areas where necessary and delineate the edges of the leaves using a fine brush. You should aim to create a clear and crisply defined painting.

Needle-leaved conifers, shown with individual needles: FROM TOP TO BOTTOM 2- and 3-needle pines; Norway spruce (*Picea abies*); Korean fir (*Abies koreana*); Douglas fir (*Pseudotsuga menziesii*); Atlas cedar (*Cedrus atlantica*); larch (*Larix decidua*).

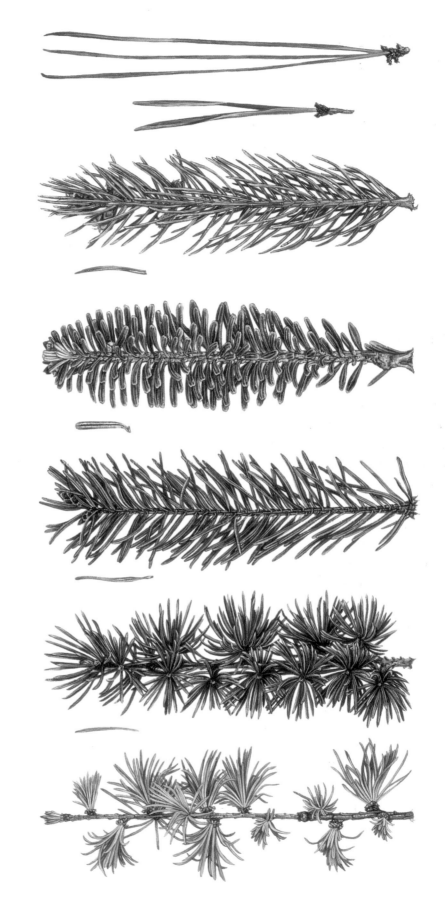

4 Add highlights, refine shadows and outlines

1 Make a detailed pencil drawing

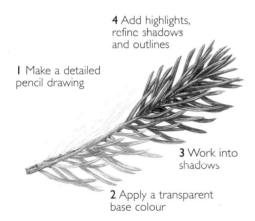

3 Work into shadows

2 Apply a transparent base colour

4 Add highlights and refine details

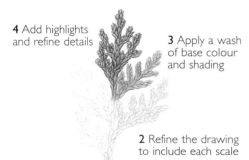

3 Apply a wash of base colour and shading

2 Refine the drawing to include each scale

1 Lightly block in outlines with pencil

Painting coniferous foliage.

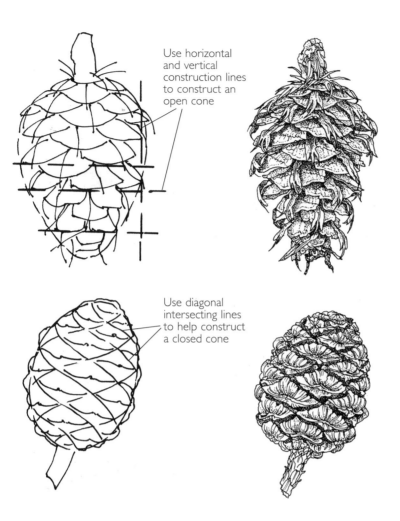

Use horizontal and vertical construction lines to construct an open cone

Use diagonal intersecting lines to help construct a closed cone

LEFT Drawing open and closed cones.

Drawing cones

The drawing of closed cones may be simplified considerably by using a network of guidelines. Draw in the outline of the cone, then draw a net of diagonal, intersecting lines across it. Ensure that the number of spaces created, and their proportions, correspond to the number of scales within your view of the cone. Using these lines as rough guidelines, draw in the scales of the cone in detail.

Open cones are more difficult to draw using this method, and tend to be best drawn using horizontal and vertical construction lines.

OPPOSITE, CLOCKWISE FROM LEFT
Scale-leaved conifers, shown with seeds and magnified shoot tips: juniper (*Juniperus recurva* var. *coxii*) with 'berries'; thuja (*Thuja* sp.) with ovoid cones; Lawson's cypress (*Chamaecyparis lawsoniana* cv.) with small, round cones; cypress (*Cupressus* cv.) with large, round cones; cryptomeria (*Cryptomeria japonica*); sequoiadendron (*Sequoiadendron giganteum*).

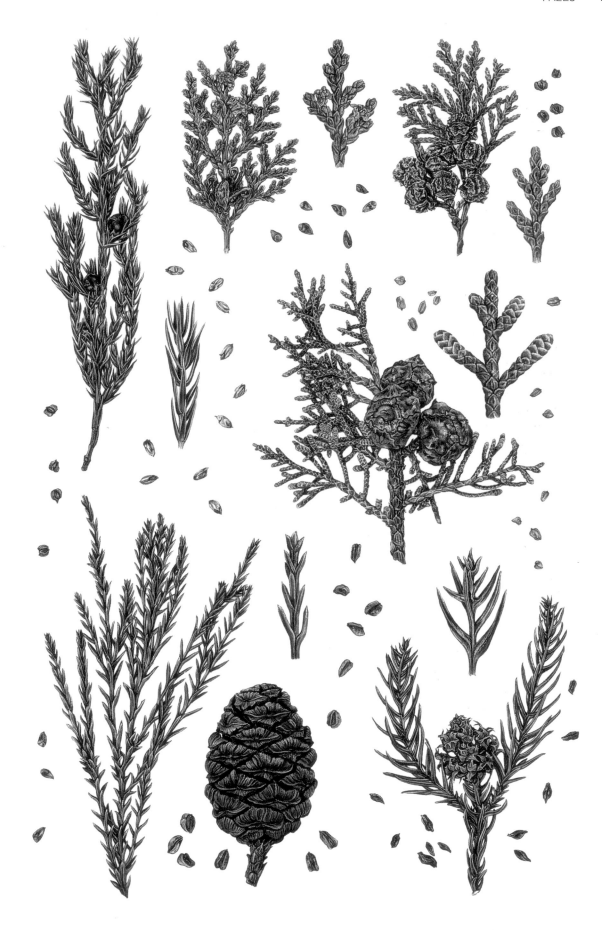

9 FUNGI

Fungi are deemed by modern biologists to be neither animal nor plant, and thus are classified in their own kingdom, Mycota. Traditionally, fungi were classified together with the kingdom Plantae for convenience's sake. However, they differ from conventional plants in two main ways. Firstly, their cell walls are made up not of cellulose but of a proteinaceous material called chitin. Secondly, they cannot make their own food by photosynthesis, as they have no chlorophyll, and so obtain nutrients by feeding on dead or decaying matter (**saprophytic**), or even living matter (**parasitic**).

Reproduction

All fungi reproduce by means of **spores**, small reproductive bodies from which a new fungal mycelium can spring. They are usually scattered by the wind and will germinate upon uptake of water. Germination leads to the growth of a fine filament from the spore that is called a **germ tube**. The germ tube grows, branches out and interweaves with those from other spores to form a mass of fine threads called **hyphae**, the structure of which is somewhat analogous to candyfloss. A **mycelium** is formed when the mass of hyphae grows together to form a netlike structure that can extend indefinitely (some mycelia are several miles across), and can support the growth of an aerial fungal fruiting body, such as a mushroom or toadstool. The fruiting body itself is made up of hyphae, and performs the function of bearing and distributing spores; thus the fungal life cycle is repeated.

Basidiomycetes and ascomycetes

Fungi are classified by the method of bearing spores, and the shape and size of those spores. There are two phyla of fungi whose members you are most likely to paint, since they are macroscopic: the Basidiomycota and Ascomycota. The difference between the two is a microscopic one:

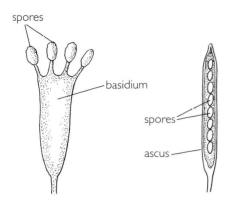

spores

basidium

spores

ascus

Basidia and asci.

basidiomycetes have spores that develop, usually in groups of four, on the outside of club-shaped cells called **basidia**, and which are simply shed when ripe; **ascomycetes** have spores that develop inside club-shaped or cylindrical cells called **asci**. When ripe, the spores are projected out of the asci.

Basidiomycete fungi

Basidiomycete fungi include agarics, boletes and polypores (bracket fungi), as well as jelly fungi and gasteromycete fungi such as puffballs.

Agaric mushrooms are perhaps the most familiar due to their wide distribution and use for culinary purposes. They present a typical mushroom- or toadstool-like fruiting body, consisting of a cap, or **pileus,** carried atop a stalk, or **stipe.** On the lower surface of the cap are gills, on the surface of which are borne basidia.

Bolete fungi also have a mushroom-like fruiting body, but on closer inspection the underside of the cap can be seen to be sponge-like, with numerous tiny pores. These form the openings of channels extending part of the way up the cap, which may best be seen by making a longitudinal section of the mushroom. The size and shape of the pores may vary from species to species; basidia line their inner surfaces. Boletes have a far shorter and more bulbous stem in comparison to agarics, and may be highly coloured; some have bright yellow flesh, which turns a deep shade of indigo-blue when cut or bruised.

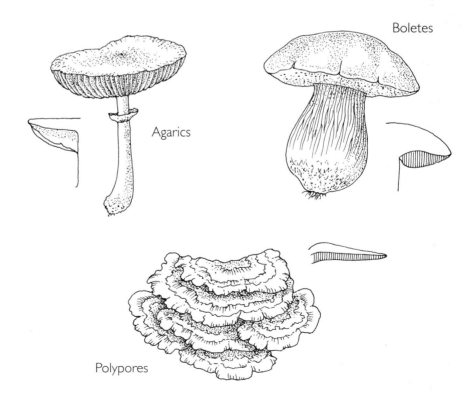

Boletes

Agarics

Polypores

Agaric, bolete and polypore fungi.

Polypores are the 'bracket' fungi found growing on trees; wood is their main substrate. Their fruiting body thus has a correspondingly tough and woody texture, rather than a fleshy one. As with the boletes, the underside of the cap shows numerous tiny pores when examined with a magnifying glass, which are likewise the openings to channels lined with basidia.

Gasteromycete fungi feature fruiting bodies that are frequently unusual, if not unique, as is their method of spore distribution; earthstars (*Geastrum*) and puffballs (*Vascellum*) distribute their spores through explosion of the fruiting body. Bird's nest fungi (*Cyathus*) are cup-shaped, which allows the spores contained within to be spread by rain splash. The end of a stinkhorn's (*Phallus impudicus*) stalk is deliberately foul-smelling in order to attract flies, which distribute the spores.

Jelly fungi grow on either living or dead wood. There is great variety in shape and size, but they are nearly always gelatinous. In dry conditions, they shrink considerably, but regain their shape and colour in moister conditions. Basidia cover the whole of their inner surface; Jew's ear (*Auricularia auricula*) has a shiny inner surface which bears the basidia, and an outer surface with a texture reminiscent of velvet.

Ascomycete fungi

All fungi in this group bear asci either on their surface or inside the fruiting body. The fruiting bodies of fungi within this group are on average much smaller than those of basidiomycetes; the group includes microscopic fungi such as yeasts, blue and green moulds, ergot of rye (*Claviceps purpurea*) and penicillin (*Penicillium*). It also includes macroscopic fungi like the colourful cup fungi (*Peziza*, *Otidea onotica*), morels (*Morchella*) and the truffle (*Tuber*).

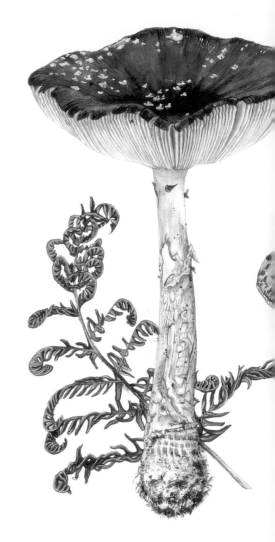

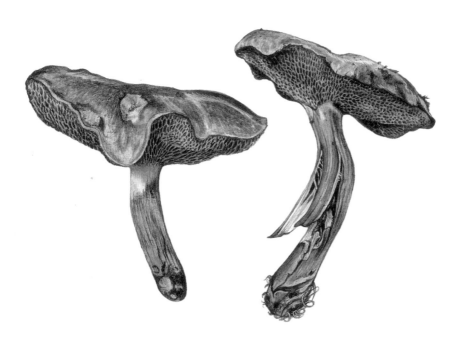

ABOVE, CLOCKWISE FROM LEFT Fungi from a location on Exmoor: fly agaric (*Amanita muscaria*); cauliflower fungus (*Sparassis crispa*); a bolete (*Boletus badius*); birch polypore (*Piptoporus betulinus*); *Lactarius turpis*; sulphur tuft (*Hypholoma fasciculare*); blusher (*Amanita rubescens*).

LEFT Jersey cow bolete (*Suillus bovinus*).

RIGHT Gasteromycete, jelly and ascomycete fungi.

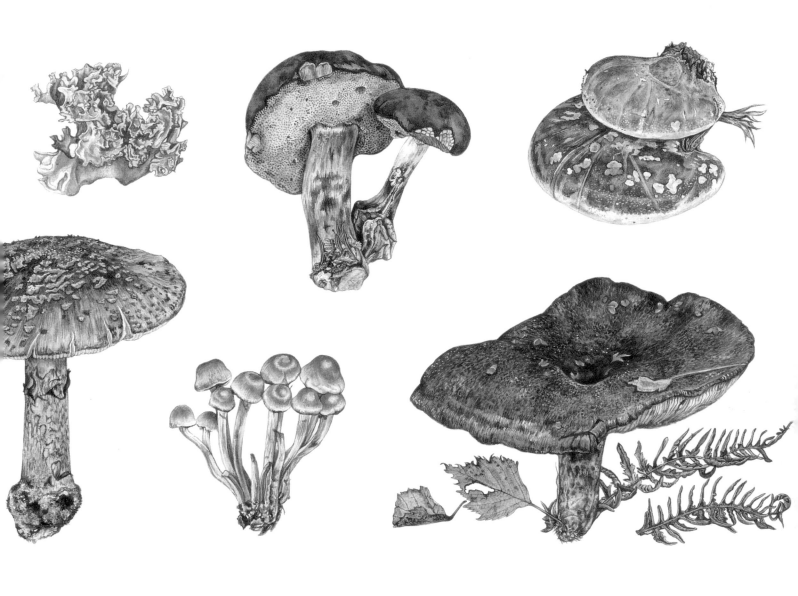

Gasteromycetes

Jelly fungi

Ascomycetes

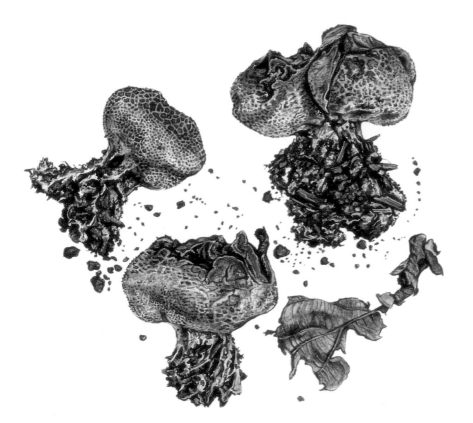

LEFT Earthballs (*Scleroderma verrucosum*).

Agaric growth and distinguishing features

Agarics are notable for their mode of development, which can be observed either seasonally, if specimens in various stages of growth are available, or by using a commercial mushroom-growing kit.

Typically, the mushroom begins to grow from a small 'button', or **primordium**. This is covered by a **universal veil**, or tough skin, that protects the mushroom at this stage. As the fruiting body develops it becomes egg-shaped, and the universal veil begins to split. Further growth results in a recognisable mushroom shape; remnants of the universal veil may be found on the cap, and also at the base of the mushroom, where they are referred to as a **volva**.

At this stage the gills may still be covered with an area of protective tough skin called the **partial veil**. When the mushroom is ripe, this splits or tears open to expose the gills; its remnants are seen as a ring on the stem.

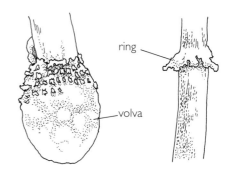

Volva and ring.

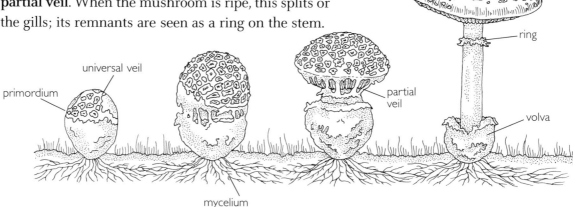

Agaric growth.

Features used to distinguish agaric fungi.

BELOW Stem sections: solid, hollow, stuffed.

solid hollow stuffed

Cap shapes.

conic domed

convex umbonate

flat depressed/uplifted

Margins.

entire wavy split

Gill attachment.

adnate adnexed

free decurrent

Stem attachment.

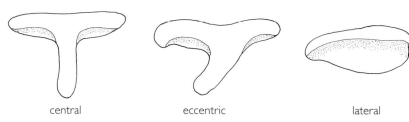

central eccentric lateral

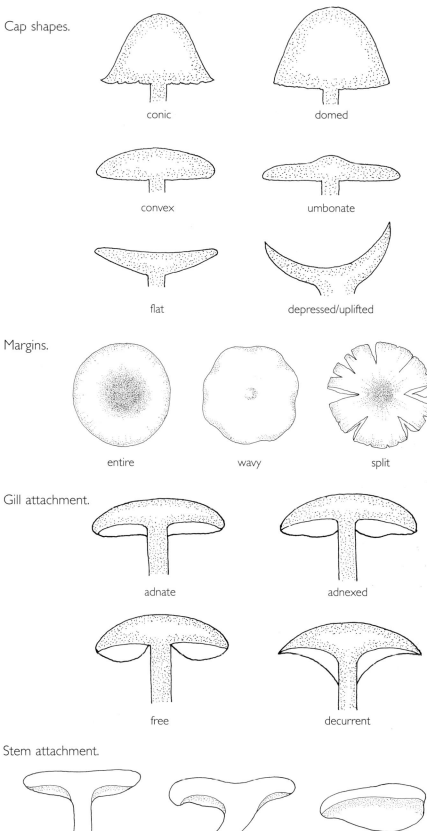

Painting fungi – white-on-white painting technique

A number of fungi are white or whitish in colour; the rendering of them on white paper is therefore a challenge. When painting any white object, it is important to render it distinct from its background; at the same time, the light colour of the object must be retained, and the illusion of whiteness created.

White objects are very rarely pure white. Examine the mushroom before you start to paint it; try to discover any additional colours that are present besides white which contribute to the local colour.

For example, the 'white' may be a yellow-white, or it may lean more towards green, pink, brown or purple. Colour tests on a piece of spare paper will be useful at this stage, through which it can be seen the small amounts of colour that are needed to tint the white of the paper. For grey shading, mix up a pale mixture of Permanent Rose and Viridian, with a touch of the additional colour that is present in the object. The colours mixed with the grey will add naturalism and warmth to the painting and prevent it from looking lifeless or monochromatic.

Begin to colour your drawing with the paint, working over the lightest areas using a light wash consisting mainly of water, with just a hint of local colour. Next, begin to shade using your mixture of grey and local colour, constantly bearing in mind that the painting as a whole must not become too dark. If shading is done to excess, the whiteness of the object will be lost; instead it will appear grey. Even the darkest tonal values in a white object will be towards the lighter end of a tonal scale. This is especially true if darker objects are included in the picture. Edges and structures should be delineated lightly with a fine brush; a uniformly thick or solid line should not be painted. Experiment with the degree of shading that is visually acceptable; in places it may be possible to darken the object more than is at first apparent, while still succeeding in making the structure appear white. Extra whitening can be effected in places by overpainting with a thin wash of permanent white gouache. This will lift the white object from the surface of the paper, and give an impression of solidity.

Fungal habitats

Fungi grow in a vast range of habitats: woodland, grassland, heaths, moors and mountains, wetlands, dunes and salt marshes. The mycelia may form **fairy rings** in grassy areas such as established lawns, or **mycorrhizal associations** with tree roots, where the mycelium of a fungus and the roots of a tree share a relationship with each other. The relationship between the

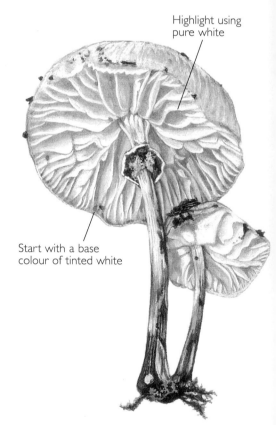

Highlight using pure white

Start with a base colour of tinted white

An example of white-on-white technique showing how the fungus is in fact white with just a hint of golden-brown. White gouache has been added in places to highlight certain areas and to enhance the luminosity of the cap.

An area of mixed woodland bordering a moor provides the ideal environment for fungi such the shaggy ink cap (*Coprinus comatus*). The tree canopy provides nutrients in the form of leaf litter and allows sufficient light penetration for a variety of mushrooms to thrive.

 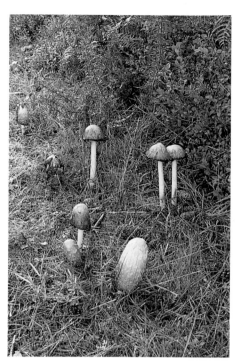

fungus and the tree may be a symbiotic one, in which each partner plays a role in nutrient breakdown and provision; or it may be a parasitic relationship, in which the fungus assumes the parasitic role and benefits at the tree's expense.

Certain fungi are often associated with particular types of tree. Fly agaric is often found together with birch and bracken on open moorland; boletes are commonly found in conifer woods.

Fungi may also forge symbiotic associations with algae to form lichens (see Chapter 10).

Collecting and making a record of fungi

The same restrictions that apply to the collection of flowering plants (see Chapter 12) do not apply to fungi. As the fruiting body develops and dies very quickly, it is almost guaranteed to have already distributed thousands of spores prior to discovery; therefore fungi may be collected without threat to future populations.

Before collecting your chosen fungi, it is useful to make sketches or take photographs of them in their natural habitat. For example, they may be growing on a rotting stump, through leaves or pine needles on a forest floor, or in grassland. Collect a small amount of fallen leaves, pine needles or tufts of grass from the fungus' immediate surroundings. These can be arranged around the mushroom to create the impression that it is growing within its native environment.

Mushrooms are highly ephemeral subjects, which, being composed mainly of water, decay notoriously quickly. It is best to attempt to paint the mushroom the same day that it is picked, although some may be preserved until the next day, or even the following week, in an airtight food-storage bag in the refrigerator. Good, crystal-clear digital photographs can also be used to preserve an image of the fungus in its fresh state. Paintings or drawings can then be made from these at leisure.

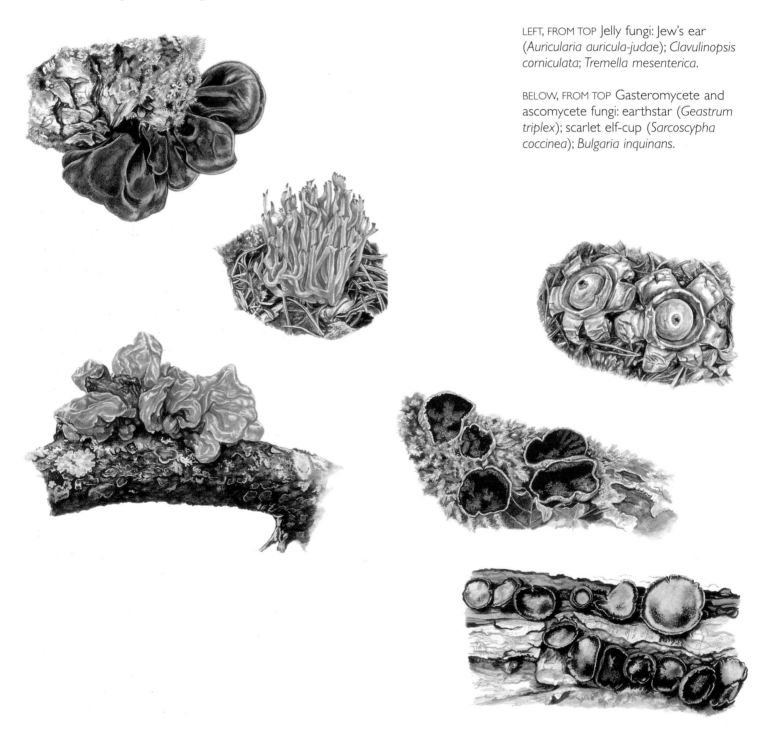

LEFT, FROM TOP Jelly fungi: Jew's ear (*Auricularia auricula-judae*); *Clavulinopsis corniculata*; *Tremella mesenterica*.

BELOW, FROM TOP Gasteromycete and ascomycete fungi: earthstar (*Geastrum triplex*); scarlet elf-cup (*Sarcoscypha coccinea*); *Bulgaria inquinans*.

10 FLOWERLESS PLANTS

The following plants do not reproduce by means of flowers or cones; instead, they reproduce through spores, or similar structures that result from the fusion of male and female cells.

Ferns

Ferns and horsetails are closely related. Both reproduce by means of spores, or by spreading underground rhizomes. The stem that arises from a fern's underground rhizomes will in turn give rise to specialised leaves, or **fronds**. Ferns are mostly perennial, so new fronds arise from the top of the stem each year; older stems will show a mass of withered leaf bases. The fronds are initially tightly coiled, and may uncoil in ways characteristic of their species; the leaf blade may be simple or undivided, as in hart's tongue (*Phyllitis scolopendrium*), or compound. If the latter, it is usually **pinnate**, where a central stem, the **rachis** or **axis**, bears numerous leaflets, known as **pinnae**, on either side of it. If these are further subdivided the frond is termed **bipinnate**.

The main vein of a fern leaf, the **midrib**, may subdivide into **secondary veins**, which may themselves further subdivide into **tertiary veins** or **venules**. Fern leaves are subject to the same terminology as that used to describe the leaves of flowering plants; the shape of fronds or pinnae is frequently a major factor in identification.

Spores are one-celled reproductive structures, akin to seeds in that an adult plant may develop from them. They develop in **capsules**, spore-carrying cases on the fronds, that form clusters called **sori**.

The sori may be differently shaped according to their species or family. They may be **linear** (*Asplenium nidus*), **reniform** or kidney-shaped (*Dryopteris filix-mas*), **peltate** or disc-shaped with a central depression (*Polystichum aculeatum*), or fused together in a line along a leaf edge to form a **coenosorus** (*Pteridium aquilinum*). They are covered by a protective sheet of tissue, termed the **indusium**. In dry conditions, the indusium dries and shrivels as the spores ripen; the sori may then take on a rustlike appearance.

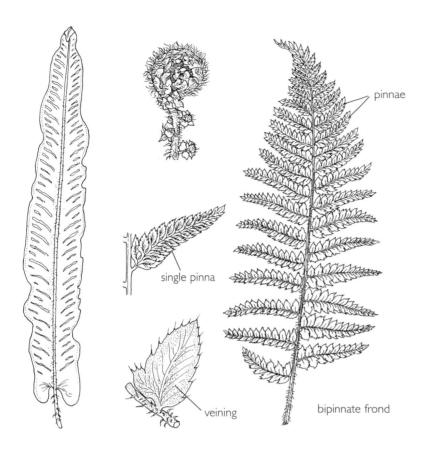

LEFT TO RIGHT Fern leaves and their anatomy: entire frond; coiled frond; fern pinna; veining; bipinnate frond.

ABOVE Shapes of sori; linear; peltate; reniform; coenosorus.

Although spores are scattered in dry weather, they can only develop in moist conditions, where a single spore will develop into a heart-shaped piece of tissue, a **prothallus**, on which male and female cells are produced at different points. Fertilisation will then occur, giving rise to a new plant.

Painting ferns

Fern material is difficult to keep fresh, and any material collected must be used reasonably quickly. The best way to preserve fern fronds is to place them into a sealed plastic bag as soon as they are picked, transferring them to a refrigerator or refrigerated bag as soon as possible. I have found that this treatment does seem to reduce moisture loss from the fronds quite considerably and keep them fresh enough until I commence painting. A cut frond that has not been subjected to this treatment wilts extremely quickly; its life may be extended for a short while by placing it on a bed made up of a sheet of plastic overlaid with polyethylene food wrap, misting it with water, and covering it with a second sheet of food wrap when the frond is not being painted.

Take photographs or make sketches to record the fern plant's form, or the environment it grows in or on, such as a wall. This information can then be incorporated into your painting in paint, ink or pencil.

Misting fern fronds with a plant sprayer.

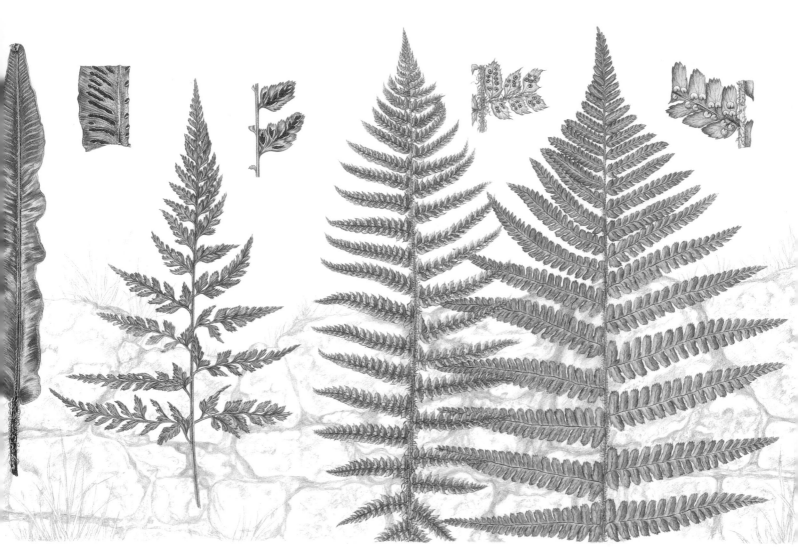

ABOVE, LEFT TO RIGHT Fern fronds against the backdrop of an overgrown wall, showing magnified views of the reverse side with sori; Hart's-tongue fern (*Asplenium scolopendrium*); *Asplenium adiantum-nigrum*; prickly shield fern (*Polystichum aculeatum*); *Dryopteris pseudomonas*. Detail of reverse side of leaves shown.

RIGHT Fern growing in its natural habitat.

It is usual to make a drawing of the upper side of the frond, alongside a magnified view of part of the reverse side showing the shapes of frond, pinnae and sori.

When making a painting of a single frond, plan the drawing by using construction lines to plot the positions of the pinnae. Block in the pinnae, and lay down construction lines according to their subdivision; try to be as accurate as possible in plotting the number of divisions. Lastly, draw in the margins of the pinnae. Closely observe any characteristics of the subdivisions; they may show a different form according to their position on the pinna.

When painting, it is important to use a finer brush size (o) for laying down the initial washes. It is also vital not to overshadow. The shapes of the pinnae are so detailed that an indication of their outlines and veining will be sufficient; trying to shadow can spoil the effect. Gouache or acrylic are the best media for portraying ferns, along with pen and ink; in the case of the latter, a simple outline drawing will be most effective.

Horsetails

Horsetails were once widespread, being common in coal forests in prehistoric times. In a manner similar to ferns, their stems arise from underground rhizomes. The stems are jointed, with hollow internodes, and ornamented with siliceous ribs; the number of ribs may vary from about 8 to 20. This number corresponds to the number of leaves, usually reduced to small scales, and the number of branches that arise in whorls from each node. Horsetails have two types of stem: the first type is a green sterile stem that bears branches, and the second type a colourless or brown stem that has spore-bearing structures similar to cones, called **strobili**. When spores are shed, they develop into a prothallus and then a mature plant in a similar manner to a fern.

Painting horsetails

Horsetails should be preserved in the same way as ferns, as they will wilt even more rapidly. It is important to make a record of them growing in their natural habitat, as this will show their truest form. Show a green sterile shoot and a brown fertile shoot if possible; ideally, present magnified views of a node and strobilus.

Plot your drawing by using construction lines to demarcate the positions of the branches in each whorl. If possible, show the leaf sheaths and branch jointing clearly. Work from the front of the plant to the back, and

Horsetail.

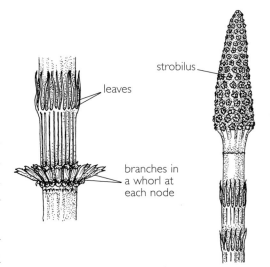

Horsetail morphology.

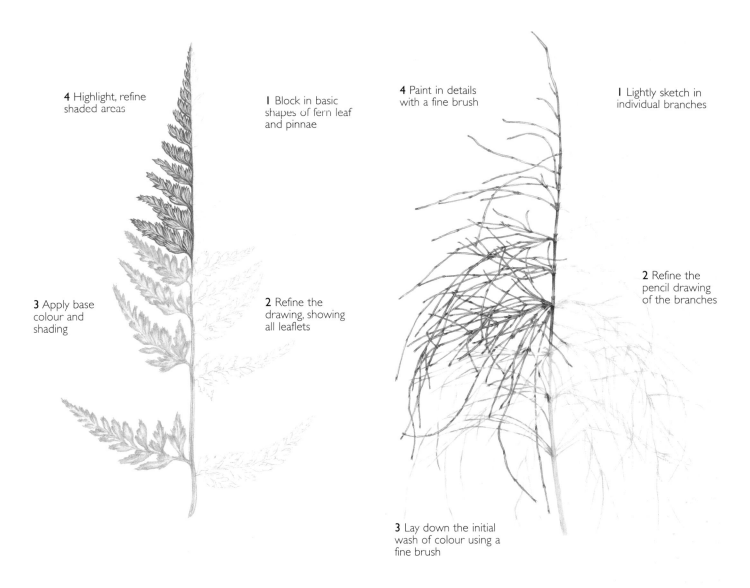

4 Highlight, refine shaded areas

I Block in basic shapes of fern leaf and pinnae

4 Paint in details with a fine brush

I Lightly sketch in individual branches

3 Apply base colour and shading

2 Refine the drawing, showing all leaflets

2 Refine the pencil drawing of the branches

3 Lay down the initial wash of colour using a fine brush

LEFT Painting fern fronds.
RIGHT Painting horsetails.

from the top of the plant to the bottom, to avoid confusion regarding direction of overlapping branches. The best medium for reproducing the delicacy of the structure is watercolour, or dilute gouache. Shading, as with ferns, should be kept to a minimum; the painting will otherwise look overworked. It is important to conserve the light, airy and complex structural appearance of these plants.

Algae: seaweeds

Algae are simple, usually water-dwelling, flowerless plants. The smallest algae, or **microalgae**, are single-celled and make up part of the planktonic content of both freshwater and marine environments.

The larger algae, those you are more likely to draw and paint, are the **macroalgae** or seaweeds. These are mainly found in marine environments.

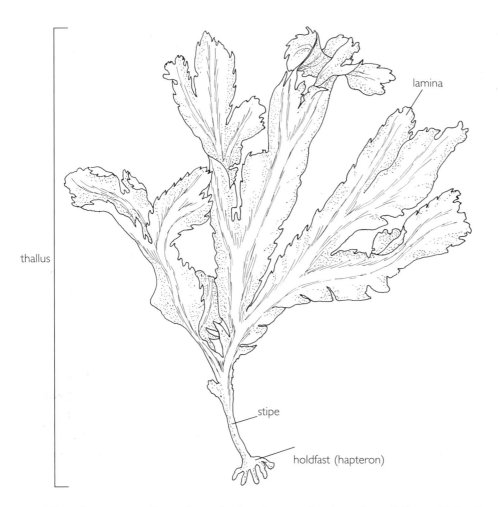

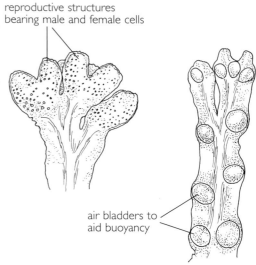

ABOVE Reproductive structures and air bladders of bladderwrack.

LEFT Seaweed morphology.

They have complicated methods of reproduction that differ widely from one species to another; in sea lettuce, the cells are released from the edge of the frond, whilst in bladderwrack the cells are contained within the frond's inflated tips; in wracks, air bladders are also present to aid buoyancy. Most seaweeds have a reproductive mechanism whereby male and female cells are released into seawater; male cells swim towards female cells and fuse with them, resulting in fertilisation.

Seaweeds have a more complex structure than microalgae. They attach themselves to rocks by a disc-shaped sucker at the end of their stem, or **stipe**, called a **holdfast** or **hapteron**. A leaflike structure called the **lamina** extends from the stipe; it may be divided (**dissected**), in which case it is referred to as a **frond**. The whole plant body is termed a **thallus**.

The thallus does not contain a vascular system as that of a land plant does, for obvious reasons: water can move freely in and out of the thallus. The thallus is therefore mainly specialised for food storage.

Seaweeds photosynthesise in the same way as land plants do. However, because light absorption is more difficult from beneath the surface of the

water, other light-absorbing pigments may be present alongside chlorophyll to increase photosynthetic efficiency. These include red and brown pigments, which if present in large amounts will mask the chlorophyll pigments sufficiently to give certain groups of seaweeds a red or brown appearance.

Seaweeds are grouped according to their colour:

Green algae (Chlorophyceae) live in shallow fresh and salt water, where light penetration is at its best. Green seaweeds may also cover the mud of estuaries. To ensure that they do not dry out upon exposure to the air, they are coated with mucilage, which makes them slippery to walk on.

Brown algae (Phaeophyceae) are almost all marine; the group includes some of the largest seaweeds, and none are unicellular. They commonly occupy the middle shore down to the low-tide mark in cool regions, carpeting the rocks. Many, such as the wracks, have tough fronds to withstand battering by waves, and air bladders to keep the fronds afloat.

Red algae (Rhodophyceae) are mainly marine and are commonest in warmer areas. They inhabit rock pools or deeper waters, and are unable to withstand much exposure to air. A range of colours, from pale pink to violet or brownish-red, are shown by red algae, as well as an equally great variety of form. Some species secrete coatings of calcium carbonate around themselves, and may be mistaken for corals. This group of algae includes the coral weed of middle-shore rock pools, laver, and Irish moss, from which carrageenan is obtained.

Green, brown and red algae.

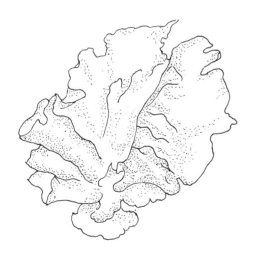

Green alga: *Ulva lactuca.*

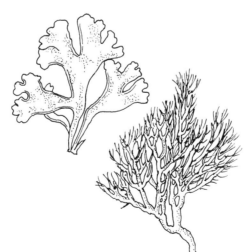

Red algae: *Cryptopleura ramosa, Lomentaria clavellosa.*

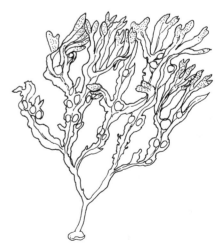

Brown alga: *Fucus vesiculosus.*

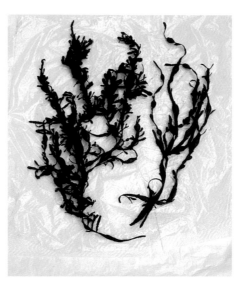

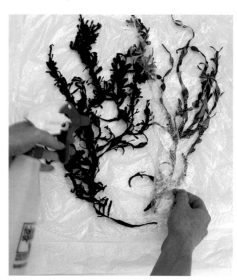

Collect seaweeds in a sealed plastic bag.

Arrange wrack fronds on plastic to give an impression of movement.

Mist the fronds and cover with a second sheet of food wrap when not painting.

Painting seaweeds

Seaweeds are prone to drying out upon exposure to air, which will affect their form. Collect tougher seaweeds, such as wracks, and keep them moist using the same method as described above for ferns and horsetails. Arrange their fronds to give an impression of movement and of growing in a natural environment.

LEFT Sea lettuce (*Ulva lactuca*).
BELOW *Cryptopleura ramosa*.

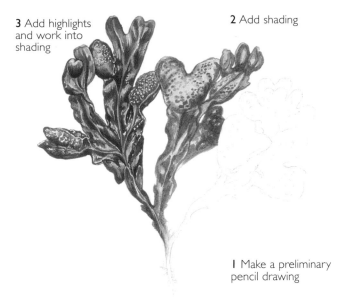

3 Add highlights and work into shading

2 Add shading

1 Make a preliminary pencil drawing

ABOVE Painting wracks.

RIGHT Bladderwrack (*Fucus vesiculosus*).

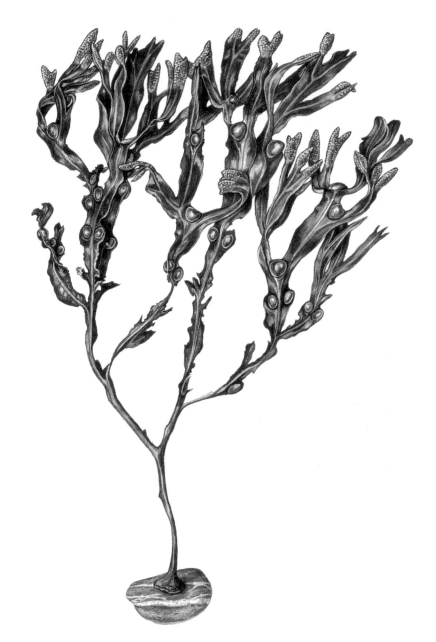

Some of the seaweeds with thinner and more delicate fronds, such as sea lettuce or laver, only show a definite shape when placed in water; out of water, they take on the shape of a rather uninteresting, limp rag. Half-fill an ice-cream tub or fish tank with water and place the seaweed in it; the shape of the thallus will then be revealed!

Try to arrange the fronds so that the seaweed appears to be growing in a watery environment. The holdfast, or hapteron, of the seaweed is likely to have become detached from its original anchorage point upon collection. If this is so, collect interestingly patterned beach pebbles, perhaps with veining or unusual textures. Combine paintings of seaweed and a pebble to create an illusion of the seaweed growing.

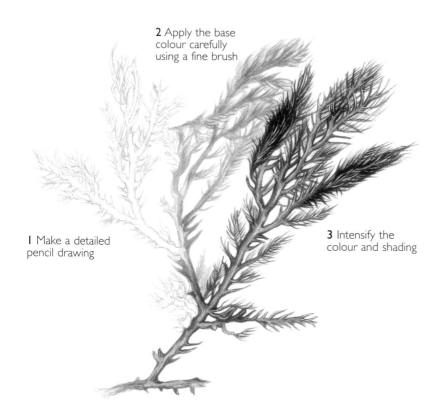

2 Apply the base colour carefully using a fine brush

1 Make a detailed pencil drawing

3 Intensify the colour and shading

A variety of green, red and brown seaweeds from the upper shore.

LEFT Painting seaweeds with finely dissected fronds.

Seaweeds are best rendered using gouache or acrylic. For wracks, these media give a solidity of appearance. An impression of the semi-shiny surface of the fronds can be given by applying a dilute layer of white gouache over a darker base coat. One way to enhance the realism and ribbon-like qualities of the lamina is to apply a non-uniform, thin white line just inside its edge with a fine brush.

More delicate seaweeds can be painted using dilute gouache and the same delicacy you would use to paint a horsetail. Take photographs of the seaweeds growing in their natural environment; it is also a good idea to take pictures of the types of rocks they grow on, which can be used in constructing a picture.

Mosses and liverworts

Like ferns and horsetails, mosses and liverworts are flowerless plants that reproduce through spores. The typical appearance of mosses is that of a leafy cushion-like structure supporting several stalks; the cushion is formed by a clump of stems, around each of which tiny leaves, or **phyllids**, are arranged in a spiral pattern. Mosses, unlike ferns and horsetails, lack true roots; in their place are fine, hairlike **rhizoids**.

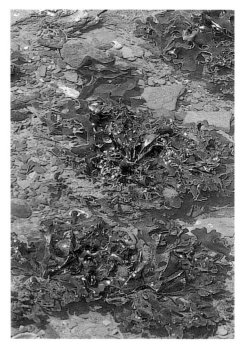

Cryptopleura ramosa, growing in the middle shore.

Moss stems produce male and female reproductive structures, which release male and female cells that fuse with each other in moist conditions. The fertilised female body develops into a stalked fruiting body, the **capsule**, which splits to produce spores; thus the moss life cycle is repeated. Identification of mosses tends to be related to the form of the capsule, and also the shape and arrangement of phyllids, since these are the features most obvious to the naked eye. Some mosses have specialised cuplike structures called **gemmae**, containing flakes of plant tissue that are distributed by water splash and thus give rise to new plants.

The largest order of mosses is the Bryales, or true mosses; most mosses belong to this group. Another prominent order, which contains only a single genus, is the Sphagnales (bog or peat mosses). Sphagnum moss carpets can hold great quantities of water, and can regulate water loss on moorland and in some woodlands on acid soil. The moss's dead stems and leaves accumulate beneath the upper, growing surface, decaying only slowly in the prevailing anaerobic conditions. Over time, the decayed vegetation consolidates to form peat. Sphagnum moss is the dominant vegetation in acid bogs, alpine and arctic regions.

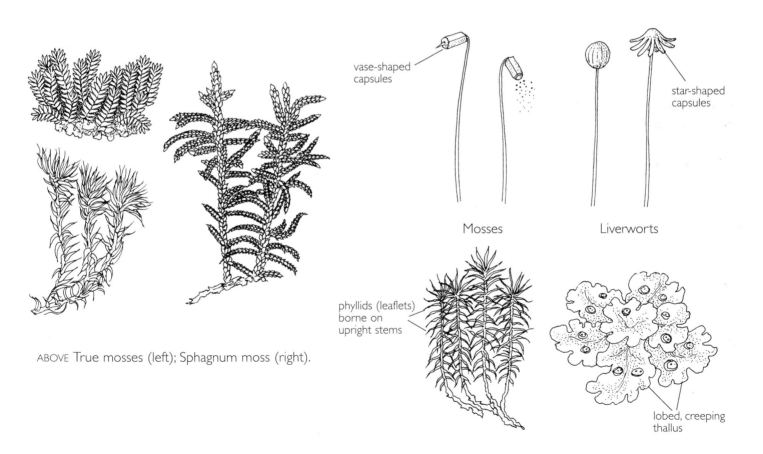

ABOVE True mosses (left); Sphagnum moss (right).

vase-shaped capsules

star-shaped capsules

Mosses Liverworts

phyllids (leaflets) borne on upright stems

lobed, creeping thallus

Moss and liverwort morphology.

Storing mosses.

Tortula muralis.

Liverworts have a leaflike stem, called a **thallus**, that creeps overground, and, like mosses, they possess rhizoids instead of roots. It reproduces in a similar way to mosses. When fertilised, its female reproductive structure develops into a fruiting body called a **sporogonium**, which dehisces and scatters the spores. Gemmae may also be present on the surface of the thallus.

Mosses and liverworts can be told apart in several ways. A moss capsule is urn-shaped, with a detachable lid that opens in dry weather to allow spores to escape. Liverwort capsules are spherical and split when mature, forming a star shape of at least four points, and often many more. Mosses have upright or creeping stems covered with small leaves which have midribs and no lobes. Liverworts are more prostrate and flattened, with much larger-lobed leaves that have no midrib.

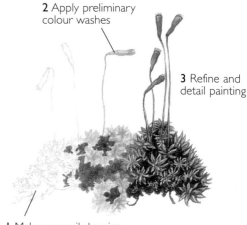

2 Apply preliminary colour washes

3 Refine and detail painting

1 Make a pencil drawing

Painting mosses and liverworts

Mosses should be placed in a moist environment during painting, or some species will shrivel. Ideally, they should be stored in a glass jar with a screw-top lid, containing a piece of moist kitchen towel to act as a wick. When painting mosses, place them on several layers of moist kitchen towel on a plastic tray, and mist them from time to time.

It is not necessary to paint every single stem in a clump of moss; a few stems that show the way in which the stem branches, together with a magnified close-up of the phyllids and capsules, are sufficient.

A small area of cushion-forming moss, with earth attached, can be depicted using acrylics or other opaque paint. I personally prefer to paint mosses using acrylics, as they lend themselves best to the high level of detail involved; it is important to convey as much information as possible. Only the finest brushes should be used at any stage of painting; parts such as the setae should be rendered as a mere single line.

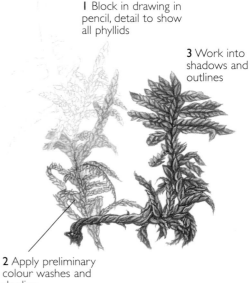

1 Block in drawing in pencil, detail to show all phyllids

3 Work into shadows and outlines

2 Apply preliminary colour washes and shading

Painting mosses.

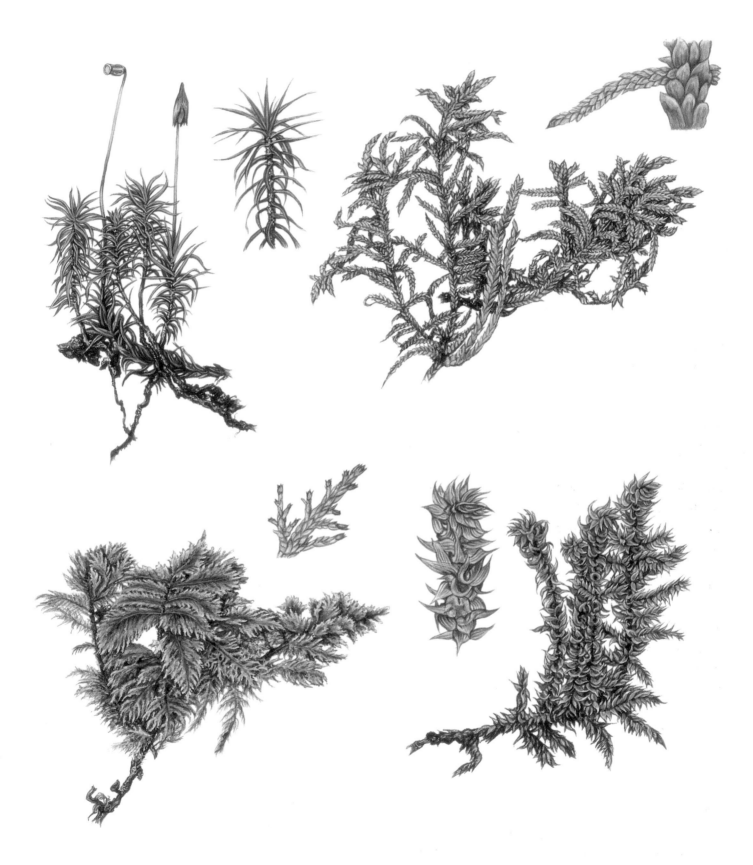

Moss species from a moorland location: *Polytrichum formosum*; a species of *Sphagnum*;
Thuidium tamariscinum; *Rhytidiadelphus triquetrus*. Stem and phyllid detail shown.

Mosses with phyllids extending up their stems, such as sphagnum mosses, must show each visible phyllid, as far as this is possible. The structure can be built up from an outline pencil drawing that is refined and reworked with subsequent washes; shading should be present in background or overlapping areas in order to give a realistic effect.

Liverworts can be kept damp in the same way as mosses, by placing them on damp layers of kitchen towel. They are usually sculptural in form, but monochromatic in colour; thus, painting them will be a matter of adjusting light and shade levels. Alongside the painting of the thallus, a magnified view of one lobe may be added to show the gemma cups, the top surface (which may be either smooth or pitted) and/or the fine white hairlike rhizoids on the underside. The semi-reflective sheen of liverworts can be achieved by painting a dilute wash of opaque paint over the green surface.

Lichens

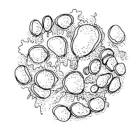

Lichens consist of a fungus and an alga or bacterium that cohabit in a symbiotic relationship. The fungal constituent, or **mycobiont**, consists of compacted threads, similar to, but much tougher than, hyphae. These provide shelter, water and nutrients for the alga. The algal constituent, or **phycobiont**, is contained within the mass of fungal threads, and photosynthesises in order to produce food for both itself and the fungus. Although the alga is capable of existing independently of the fungus, the reverse is not possible. The whole algal–fungal structure is called a **thallus**.

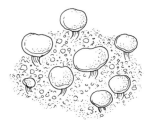

Since the greater part of the lichen is composed of a fungus, lichens are considered to belong to the fungal kingdom. However, lichens differ considerably from fungi. A lichen's growth is extremely slow, and the lichen body is also tough and dry, unlike that of most fungi; they enter a dormant state in times of drought, and can withstand almost total desiccation.

The lichens take on the type of spore-bearing fruiting body corresponding to the fungal constituent, which will be of a basidiomycete or an ascomycete type and is called an **apothecium**; at a microscopic level,

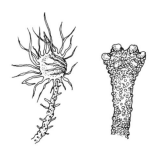

Basidiomycete and ascomycete lichens; spore-bearing structures.

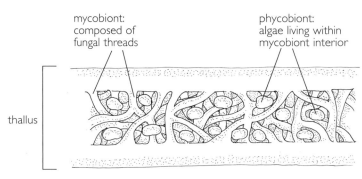

mycobiont: composed of fungal threads

phycobiont: algae living within mycobiont interior

thallus

LEFT Structure of lichen interior.

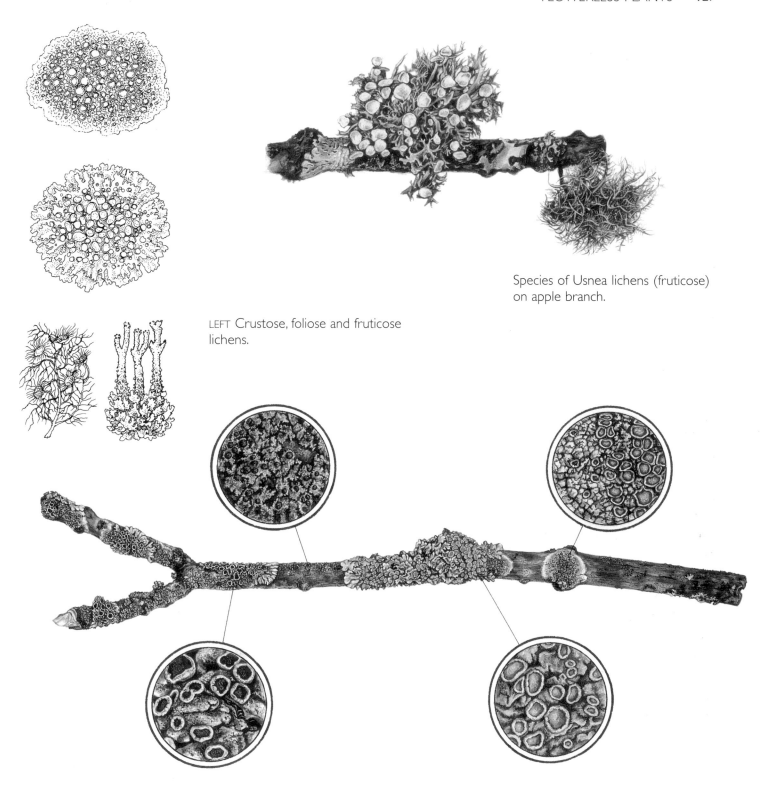

Species of Usnea lichens (fruticose)
on apple branch.

LEFT Crustose, foliose and fruticose
lichens.

Species of crustose and foliose lichens
from an apple branch, with magnified
views (magnification unspecified) of
lichen species.
CLOCKWISE FROM UPPER LEFT
Lecanora conizaeoides; *L. campestris*;
L. atra; *Xanthoria parietina*.

basidiomycete-type lichens appear to have miniature mushroom-shaped
apothecia growing on their surface. Spores can only become lichens if
scattered in the vicinity of a corresponding alga. Most lichens reproduce
by distributing outgrowths of tissue called **isidia**, similar to the gemmae
of mosses and liverworts, or granules called **soredia**, which emerge from
cracks in the thallus.

Lichens fall into three different categories: **crustose** lichens, which form a crustlike coat on rocks or other surfaces, and break into polygonal, usually hexagonal, plates; **foliose** lichens, which are made up of many scales or lobes resembling leaves, and may form circular patches; and **fruticose** lichens, which resemble small bushes or trees, and form tufts.

Painting lichens

Lichens appear complicated to paint, but need not be if a methodical approach is taken. Most will dry out fairly slowly and thus will not change their shape or colour rapidly, with the exception of dog lichens (Peltigera), which need to be treated in a similar manner to mosses and misted frequently. Fruticose lichens are often present on prunings from fruit trees in unpolluted areas, whereas foliose or crustose lichens may be present on loose stones; since lichens dry out slowly, you can take a small sample of the latter to paint and then replace them at a later date.

The most important structures of the lichen, such as the outline, the main branches, or distinctive or large apothecia, will need to be blocked in prior to refining the drawing, and will serve as reference points. Lichens are best painted using opaque paint – my preferred choice being acrylic – and a fine brush. With fruticose lichens, it is best to cover the entire drawing with a base colour, working into shadows and highlights consecutively. Foreground details should be more clearly defined than background details; this will enhance the three-dimensional effect. Lastly, scaling up drawings or paintings of lichens is often more practical in terms of both preserving your eyesight and achieving a successful result.

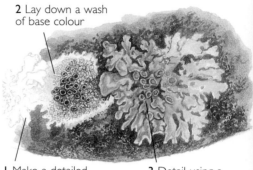

2 Lay down a wash of base colour

1 Make a detailed pencil drawing

3 Detail using a fine brush

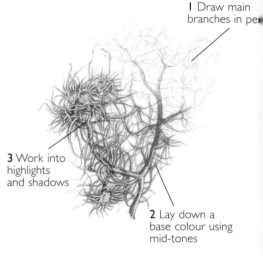

1 Draw main branches in pe[n]

3 Work into highlights and shadows

2 Lay down a base colour using mid-tones

Painting lichens.

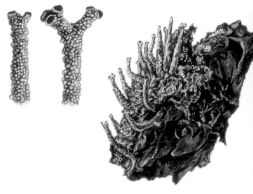

FROM LEFT Species of Cladonia lichens: *Cladonia fimbriata*; *C. bellidiflora*; *C. coniocraea*.

11 PRESENTING YOUR WORK

Portfolios and Presentation Cases

In order to store and transport your original works safely and keep them in a presentable, clean state, you will need an A2 or A3 size portfolio or presentation case. A1 portfolios are suitable for larger work, but if you are lightly built you may find them heavy and awkward to carry. For transportation and other practical reasons, therefore, it may also be a good idea to tailor the size of your work accordingly (see Chapter 5).

Do not choose the very cheapest portfolio available, as the sides of these are often made of little more than laminated card, and thus, with very limited waterproofing, they warp easily and become battered within a very short time. The zips also have a tendency to break! A good portfolio should be well finished, robust, and have a protective outer covering; it should stand up to several years of wear and tear. Take care not to over-fill a portfolio or presentation case, as the handles may eventually break.

Portfolios are the lower-budget method of transport; they do not include a ring binder, but may contain several display pockets or strips of elastic to divide work and ensure that it remains flat. Loops or pockets to carry various sketching materials may also be supplied.

Presentation cases are more expensive and include an integral ring binder, which will hold proprietary plastic sleeves with black paper inserts; these are usually sold separately from the portfolio. Pieces of work can be displayed by inserting one piece on each side of the sleeve. This procedure will help keep your work safe from moisture, grease, grubby finger marks and inadvertent creasing.

Trim your work further, if desired, before displaying it in your portfolio. Ensure that there is still sufficient margin (2.5–5 cm/1–2 in) left all the way round to allow for framing or handling. The paper should be clean and free of stray pencil, paint or finger marks, and dog-ears!

An A2 presentation case and A3 portfolio.

A presentation case, with integral ring binder and plastic sleeves.

Organising your portfolio

It is standard practice to present your work to potential clients unmounted, as this will better enable them to visualise potential uses for it. To create a good first impression, it is also important to invest a little time and thought in the organisation of your portfolio.

Lay out all your pieces of work on a suitable flat, clean and dry surface and select those you feel to be your best. Arrange your portfolio so that at least three or four of your best pieces of work are placed first; this will be the first thing a client sees, and is likely to affect their initial impression. Likewise, place several better pieces towards the middle, and also at the end. It is a good idea to group your work into themes or colours, so that a smooth progression from one theme to the next is effected. For example, two monochromatic pieces may be placed adjacent to or following one another, or paintings of flowerless plants may be displayed together.

As you produce more work and your painting technique improves, make a point of reviewing and rearranging your portfolio from time to time. Practise talking about your work and evaluating it. You may mention factors that influenced the work, such as the reasons that motivated you to paint a particular subject. These may be a fascination with the subject's colours, a desire to paint the flora of a particular area, or the goal of exploring a specific theme; or they may centre around the medium that the subject was painted in, and its ability to enhance the visual qualities of the subject.

A typical portfolio, showing elastic dividers.

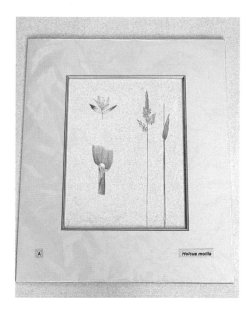

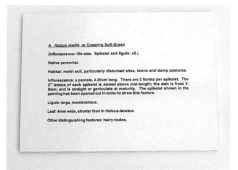

A watercolour mounted and wrapped in cellophane for exhibition, with an accompanying sign to describe the species.

Exhibitions

If offered for sale or for an exhibition, your paintings or drawings ideally should be mounted. Choose a colour for the mount that enhances the work, but is simultaneously unobtrusive and does not compete with it. Good examples would be: a white mount with a single or double gold line ruled $\frac{1}{4}$ in. from the inner edge; a double mount in harmony with the dominant colours of the work, where the darker colour of the two forms the inner edge; or a cream or white mount with a gold slip.

If the paintings are to be mounted but not framed, you will need to protect the mounts, particularly if they are pale-coloured, by wrapping them in cellophane. This will ensure that they remain crisply clean and pristine. If the painting is to be framed, a frame that complements the mount and picture is appropriate; frames with a minimum of ornament are preferable. Gold is highly recommended if gilding is present any-where on the mount. If hanging systems are not available, a good secure display may be created by attaching appropriately sized mirror plates to the back of the frame.

Labelling criteria may be set out by the exhibition organiser, since at times you may be called on to provide your own labelling. Labels can be made from computer printouts on good-quality ink-jet paper or card, and cut to size. Furthermore, the font or text style and size can be adjusted, Arial being a good choice due to the ease with which it can be read. Using a steel ruler, paper knife and board, the labels can be cleanly excised. They may then be attached to the lower right- or left-hand corner of a wrapped mount with a non-permanent glue stick, or to the correspon-ding corners of a framed picture with adhesive tack.

If more detailed information is needed about the exhibits, and a pro-fessional-looking appearance is desired, signs can be printed to order by a signage company on 3 mm vinyl. They are light enough to be attached to hessian-covered backdrops using sticky-backed Velcro®, or to smooth surfaces such as painted wooden exhibition boards using double-sided sticky pads. Due to their wipeable surface, they will also tend to remain in pristine condition for longer than paper or card signs.

It is often desirable to centre the display of pictures around a coher-ent theme, and to include background information relating both to the theme itself and also to the subjects depicted. For example, the illustra-tion on this page shows one picture of a series of eight grasses from a Somerset roadside location. The picture has been mounted and wrapped, numbered with its position in the series and labelled with the appropri-ate botanical nomenclature.

The signs shown have been printed in Arial type on 3 mm vinyl. The smaller sign contains information relating to the species depicted in the

painting, whereas the larger sign, which would ordinarily be placed at the start of the display, shows a map of, and information relating to, the area in which the grasses were found, together with a species list.

The hanging of pictures may be effected in a variety of ways, and is dependent largely upon the nature of the venue. It is useful (although not always practical) to visit the venue well in advance and ensure that it is well lit, with a low humidity. This will reduce the likelihood of undesirable events such as cockling of the paper or warping of the backs of the frames. Occasionally, high humidity may be unavoidable. It can be reduced to some degree by using conservation board to back framed pictures, by choosing paper over surfaces such as vellum, and by displaying paintings of a smaller size; following these measures will make cockling less likely to happen.

Consideration must also be taken of the backdrop or exhibition board. Mentally, or on a piece of paper, sketch out and clarify the hanging or displaying systems available and the way in which your chosen pictures can be hung using these systems. Test the hanging systems beforehand if possible, to ensure that you will be able to achieve the most stable and aesthetically pleasing display; observe the display systems other artists use in their exhibitions.

Prints and cards

You may decide to approach companies to produce commercial prints and cards from your work. However, they will usually stipulate a print run of a minimum number of prints or cards per design, and can charge several hundred pounds for printing. Before embarking on such a venture, you will need to have some indication of whether your type of work would be likely to sell well; in some cases it may even be more prudent to sell an original, rather than cards, when production costs are taken into consideration.

If you do decide to pursue the production of prints or cards, their presentation should be approached with the same level of professionalism that you would apply to the presentation of an original work. Mail-order printing companies often provide information packs that include samples of their work. Cards should be provided with a suitably sized envelope and presented to you in cellophane bags. If your cards are printed commercially, envelopes and a wrapping service may be included in the price.

Prints should ideally be mounted for sale. They need not be framed, but will benefit from a protective cellophane wrapping. Before the print is wrapped, it should be signed and labelled with its number within the print run (for example, 156/250).

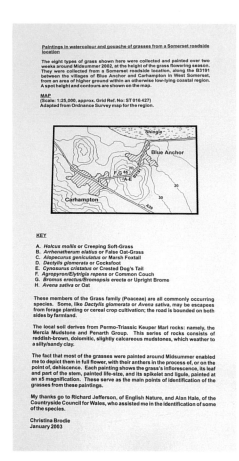

Sign printed on 3 mm vinyl, showing a map, a description of the area and a species list.

12 FURTHER STUDY

Themes

It is good practice to build up a portfolio of pictures of subjects with interlinking themes. For example, the subjects might all be from different genera of the same plant family, thus showing a number of typical similarities and differences; or they might be plants found at a specific geographical location, which can be an exotic archipelago, a botanical garden, or simply a roadside verge. Paintings of these plants made over a period of time will gradually provide a record of the flora of the location.

Making an ecological study

An ecological study is made from wild plants growing in environments that are not horticultural. It can be carried out over a wide area, such as a national park, or it can focus on smaller marginal areas like disused railway lines, wasteland, roadsides, canal sides or the banks of a stream; and more obviously rural locations, such as stretches of coastline or seashore, mountains, hills or moorland, a patch of coniferous or deciduous forest, farmland or a hedge.

The best place to start making an environmental study is within the environment that is most immediate to you. Take several walks around your environment, observing wild plants that grow there and making sketches, or taking photographs, of any that catch your eye. It will not necessarily matter whether they are wild, or escapees from cultivation; the aim is to provide a record of the area at a particular point in time. Examine the plants closely, and try to identify them with the help of your field guide, or collect samples to identify later.

Note the frequency with which each species occurs; does one species predominate, or is there a more evenly balanced mixture? Visit the area regularly and note the times of flowering and setting seed.

An area behind the ridge, where fresh water meets salt, home to rushes and glassworts.

Rushes (*Bolboschoenus maritimus*), with glassworts (*Salicornia europaea*) growing at base.

Low-lying pasture, with sea aster (*Aster tripolium*).

You may observe that flowering periods are not evenly balanced throughout the year. The best opportunities for painting wild flowers in Britain generally occur from about April to September. Fruits will be retained for an average of six to eight weeks following a plant's flowering. This will mean that, given the length of time it takes to complete a botanical painting, a selection must be made from the plants available for painting. The often enormous choices will need to be narrowed down; one year you may choose to paint grasses, the next year plants from the pea family, and so on. If several of your chosen plants are blooming simultaneously and within a short period of time, paintings may need to be completed at considerable speed, or finished later with the help of annotations or photographic information.

Often your guidebook will not show every species you discover; it is therefore important to take a variety of guidebooks or make a detailed drawing of the species in question. You may be able to identify it at a later date by consulting a more detailed guide, or a professional specialising in the ecology of the area.

When making an environmental study it is appropriate to depict the plant in its natural setting. Take photographs of the whole plant growing in its environment. These must be as clear as possible, using a tripod if necessary, so as to enable you to produce a good painting or drawing from them. They will provide an accurate record of the whole plant from which to work. If the plant is small, a macro lens or zoom feature on a digital

These photographs show a coastal environment composed of a strip of shingle deposited at the end of the last Ice Age, through which the sea is allowed to penetrate and flood the low-lying areas behind. This has given rise to a particular xerophytic, or salt-tolerant, flora.

Sea aster (*Aster tripolium*).

Close-up of lower-growing flora:
greater sea spurrey (*Spergularia media*),
sea purslane (*Atriplex portulacoides*).

Glassworts (*Salicornia europaea*).

camera may be needed to capture detail. Also, take photographs or make sketches of the landscape that the plant is growing in; this could be on a cliff face or mountain top, on a wall or by a fence. You may want to put this landscape in your picture as a backdrop, painted in the same medium that you have used for the plant subject, or drawn in a monochrome medium such as pencil or ink. A map may be integrated into the painting.

Organisations and contacts for ecological studies

The following British and American organisations are concerned primarily with the conservation, ecology and study of wild plants.

BSBI (Botanical Society of the British Isles) – Produces atlases and county floras showing the distribution of plants, and also the scientific journal *Watsonia*. It holds conferences on botany and runs an education programme incorporating fieldwork. *BSBI, Botany Dept, Natural History Museum, Cromwell Rd, London SW7 5BD.*

English Nature – A governmental agency concerned with the conservation of wildlife and geology throughout England. In 2007 it will be merged with the Rural Development Service and other environmental agencies to form the organisation Natural England. This single body will

retain most of the powers of English Nature including the designation of SSSIs (Sites of Special Scientific Interest), AONBs (Areas of Outstanding Natural Beauty) and national parks; the distribution of grants; and the enforcement of environmental regulations. *English Nature, Northminster House, Peterborough PE1 1UA.*

FSC (Field Studies Council) – An environmental education charity providing practical courses in the identification of plants and fungi both through centres in the UK and courses overseas. *FSC Head Office, Montford Bridge, Preston Montford, Shrewsbury, Shropshire SY4 1TW.*

Botanical Society of America – Provides and promotes education and expertise in the field of botany, through publications, meetings and committees. *Botanical Society of America, PO Box 299 St Louis, MO 63166-0299.*

A study of halophytic flora from a coastal marshland area, made using good digital photographs.

FROM LEFT TO RIGHT sea club-rush (*Bolboschoenus maritimus*); thrift (*Armeria maritima*); sea aster (*Aster trifolium*); spear-leaved orache (*Atriplex prostrate*); greater sea spurrey (*Spergularia media*); sea purslane (*Atriplex portulacoides*); glasswort (*Salicornia europaea*); spearmint (*Mentha spicata*).

Collecting plants in the field

It is best to use common sense and discretion when collecting plant material for the purposes of recording it. As a rule of thumb, it is advisable not to pick plants unless they are very common everywhere. Their abundance in a particular area may disguise their rarity elsewhere; in fact, the site may have been designated an SSSI, in which case the plants

This painting of moorland plants observed on a walk in north-western Jersey was also made from digital photographs, using the zoom feature on a digital camera. A map in ink and pencil, and a small piece of the indigenous granite, has also been included. From top to bottom, the flora are: horseshoe vetch (*Hippocrepis comosa*); *Polygala serpyllifolia*; lousewort (*Pedicularis sylvatica*); buck's horn plantain (*Plantago coronopus*).

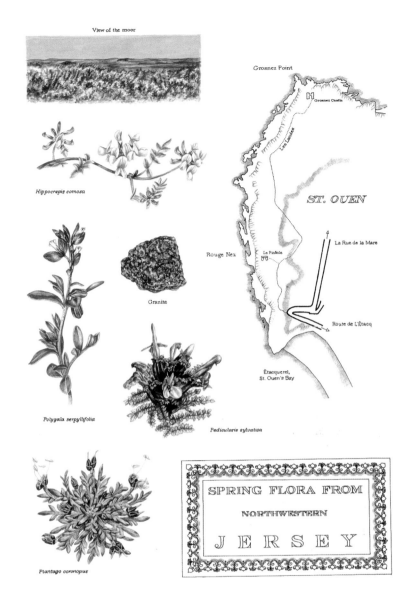

should not be picked, but sketches and photographs made instead. This is true even if the species itself is not protected, as it may form part of a very typical floral profile which it is necessary to preserve. Technically speaking, in Britain it is illegal to uproot plants from the wild, but not illegal to pick a small sample of most plants, provided that there are sufficient specimens of the same species within the immediate vicinity; this will ensure that the plant has a chance to flower and set seed. There are exceptions to this rule; these include orchids, and plants from a protected site. Unless the plant is very common, it is best to err on the side of caution and work from sketches and photographs only. A good traditional camera with a macro lens, or a digital camera with a zoom lens, will enable you to focus on plant parts at close range and record enough information to make a detailed painting from the photographs.

If you are collecting material, gather as much as can be comfortably painted in the time available, so that the plant material will not decay before it can be recorded.

To recreate the plant's natural environment, a minute sample of the surrounding vegetation or environment may be taken, such as earth, leaves or pine cones if the plant is growing in woods; blades of grass if the plant is growing in a meadow; or pebbles or scree if the plant is growing on a beach or on waste ground.

Making a horticultural study

Horticultural studies may be made at botanical gardens or at national plant collections. Permission to paint should always be sought prior to commencing your study, from the owner, proprietor or head gardener. Familiarise yourself with the garden or collection by visiting it at several times of the year. Make annotated notes as you would for an ecological study.

Identification is by and large likely to be easier than with an ecological study, due to the familiarity of gardening staff with the plants grown. National plant collections devote themselves to the study of either a single genus or a small number of genera. In-depth knowledge about the genus and the species grown will therefore be readily available, and may be presented alongside a subsequent exhibition of paintings. Aim to learn as much about the genus as you possibly can during your study.

Certain gardens may also be famous for their propagation of certain plant genera, or may have a feature such as a lake, stream or arboretum with a distinctive flora.

Organisations and contacts for horticultural studies

The list below shows several organisations in Britain and America concerned with horticultural studies and the conservation of plant species of horticultural value.

Kew Gardens – The main botanical research institution in the British Isles, housing extensive plant collections and the Millennium Seed Bank, and providing botany-related education up to postgraduate level, operating from its two centres. *Royal Botanic Gardens, Kew, Richmond, Surrey TW9 3AB; Wakehurst Place, Ardingly, Haywards Heath, West Sussex RH17 6TN.*

The gardens at Dunster Castle, Somerset, England, are home to a steeply sloping terraced garden with a subtropical terrace. They boast the National Collection of Arbutus, and an outstanding display of hydrangeas.

Palms on the subtropical terrace.

The Keep Garden, atop a concealed reservoir.

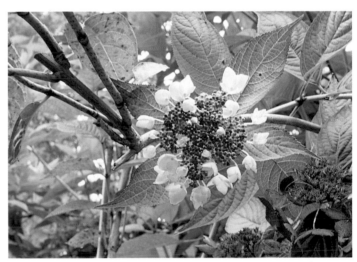

Gunnera in the lower garden.

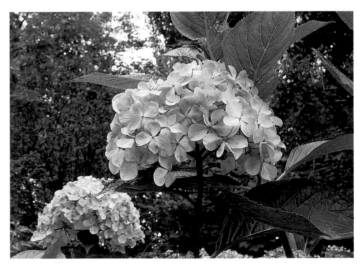

The fountain adjacent to the Orangery.

TOP TO BOTTOM Hydrangeas from one of the garden walks.

National Trust – An organisation concerned with the conservation of heritage sites such as historic buildings, gardens and coastlines. *The National Trust, 36 Queen Anne's Gate, London SW1H 9AS.*

NCCPG – National Council for the Preservation of Plants and Gardens. This conservation charity upholds, through national plant collections, the preservation of traditional garden plants, and their varieties, that are in danger of disappearing. Curators of the collections will devote part of their time to specialising in plants of a single genus; this will involve a degree of scientific research. *NCCPG, Stable Courtyard, Wisley Garden, Wisley, Woking, Surrey GU23 6AP.*

RHS – Royal Horticultural Society, a charity concerned with the promotion of horticulture and good gardening practices. RHS gardens include Wisley in Surrey, Rosemoor in Devon, Hyde Hall in Essex, and Harlow Carr in North Yorkshire, among others. Gardening shows are held both at the Horticultural Hall in London and the NEC in Birmingham; botanical drawings and paintings may be exhibited at both of these venues, with the chance of winning a Bronze, Silver, Silver-Gilt or Gold award. Details of how to exhibit may be obtained from the following address: *RHS, 80 Vincent Sq., London SW1P 2PE.*

American Horticultural Society – One of the oldest horticultural organisations in the USA, the AHS promotes horticulture through education, events and activities. *AHS, 7931 E. Boulevard Drive, Alexandria, VA 22308.*

SUPPLIERS

Most of the materials suggested throughout this book should be readily available at local art suppliers or dealers. However, items such as hot-pressed illustration board and scraperboard (or scratchboard) are less easily obtainable. They can be mail-ordered from the following sources:

UK

Hot-pressed illustration board (Daler-Rowney CS2, Line & Wash):
London Graphics Centre
16–18 Shelton St
London WC2H 9JJ
www.londongraphics.co.uk.

Essdee Scraperboard (professional grade):
Oasis Art & Craft Products Ltd
Gold Thorne Rd
Kidderminster
Hereford & Worcester
DY11 7JN

Microscopic equipment, dissection kits, slides (also supply to US)
Brunel Microscopes Ltd
Unit 2, Vincients Rd
Bumpers Farm Industrial Estate
Chippenham
Wiltshire SN14 6NQ
www.brunelmicroscopes.co.uk

US

Illustration board (Crescent) and Essdee scratchboard:
Dick Blick Art Materials
PO Box 1267
Galesburg
IL 61402-1267
www.dickblick.com.

BIBLIOGRAPHY

Bailey, Jill (ed.), *The Penguin Dictionary of Plant Sciences* (new edn) (London: Penguin Books, 1999), (originally pub. as *The Penguin Dictionary of Botany*). ISBN 0-14-051403-1.

Blunt, Wilfrid, *The Art of Botanical Illustration* (1st edn) (London: Collins, 1950).

Hickey, Michael, and King, Clive, *Common Families of Flowering Plants*, (Cambridge: Cambridge University Press, 1997). ISBN: 0-521-57609-1.

Masefield, G.B., Wallis, M., Harrison, S.G. and Nicholson, B.E., *The Illustrated Book of Food Plants* (London: Peerage Books, 1985), (originally pub. as *The Oxford Book of Food Plants*). ISBN: 1-85052-017-8.

Mitchell, Alan, *Trees of Britain and Northern Europe* (Collins Field Guide) (2nd edn), (London: HarperCollins Publishers, 1978). ISBN: 0-00-219213-6.

Nicholson, B.E., and Brightman, F.H., *The Oxford Book of Flowerless Plants*, (London: Peerage Books, 1985), (originally pub. Oxford University Press). ISBN 0-907408-46-X.

Phillips, Roger, Shearer, Lyndsay, Reid, Derek and Rayner, Ronald (ed.), *Mushrooms and Other Fungi of Great Britain and Europe* (London: Pan Books, 1981). ISBN: 0-330-26441-9.

Vanderplank, John, *Passion Flowers* (2nd edn) (Clevedon: National Collection of Passiflora, 1996). ISBN: 0-304-34216-5.

West, Keith, *How to Draw Plants: the techniques of botanical illustration* (London: The Herbert Press/The British Museum (Natural History), 1983). ISBN 0-906969-78-6.

INDEX